IMAGES
of America
SANTA MONICA
LIFEGUARDS

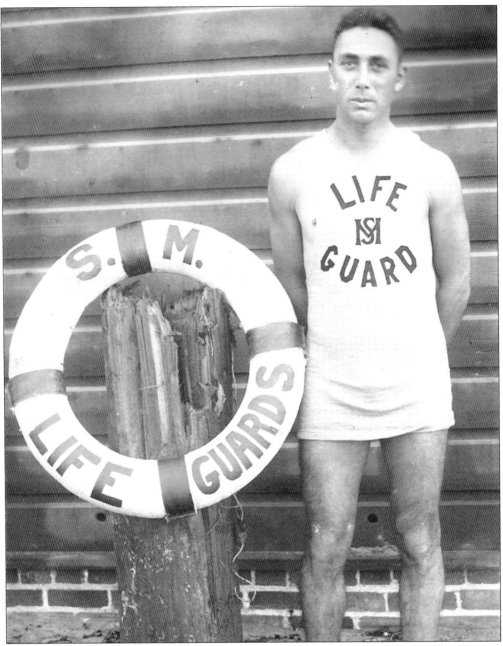

Although the Santa Monica Lifeguard Service was not officially begun until 1932, volunteer lifeguards were patrolling Santa Monica Beach as early as 1905. In this photograph, c. 1912, a member of that very first group stands proudly next to a recently painted life ring.

ON THE COVER: Members of the 1932 Santa Monica lifeguard crew walk towards the camera on the world-famous Santa Monica Pier. Wearing the chief's hat is the legendary "Cap" Watkins, who was the leader of the Santa Monica lifeguards from its offical inception in 1932 to his retirement in 1955.

IMAGES
of America

SANTA MONICA LIFEGUARDS

Arthur C. Verge

Copyright © 2007 by Arthur C. Verge
ISBN 0-7385-4698-4

Published by Arcadia Publishing
Charleston SC, Chicago IL, Portsmouth NH, San Francisco CA

Printed in the United States of America

Library of Congress Catalog Card Number: 2006933255

For all general information contact Arcadia Publishing at:
Telephone 843-853-2070
Fax 843-853-0044
E-mail sales@arcadiapublishing.com
For customer service and orders:
Toll-Free 1-888-313-2665

Visit us on the Internet at www.arcadiapublishing.com

This book is gratefully dedicated to legendary news journalist and photographer Bill Beebe, whose support and generous donation of numerous historic photographs has made it possible to preserve the history of the lifeguard service.

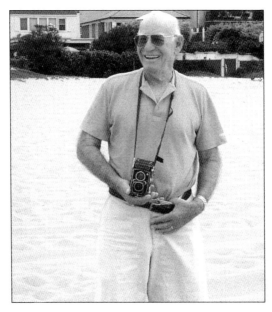

All proceeds for this book go to the Los Angeles County Lifeguard Trust Fund for Public Safety and Education.

Contents

Acknowledgments 6

Introduction 7

1. Every Swimmer a Lifesaver (1905–1919) 9
2. Ain't We Got Fun (1920–1929) 19
3. Hard Times and Good Times (1930–1945) 25
4. From War to Wealth (1945–1960) 51
5. Surf City—Here We Are (1961–1973) 85
6. Three Lifeguard Services Become One (1974–2006) 103

Acknowledgments

This book has been made possible by the generosity of a wide range of individuals and organizations. I am especially grateful to the Los Angeles County Lifeguard Trust Fund and to Chief Dave Story for funding expenses associated with producing this book. A very special thank you goes to retired lifeguard captain Nick Steers, who guided this project to completion. I cannot say thank you enough for all the work he and his wife, Joyce, did to make this book a reality.

Thank you to Dave Kastigar, Elayne Alexander, and Chief Bud Bohn for all of their hard work to research and preserve the history of three lifeguard services. To the always helpful Ho Nguyen, Andrea Engstrom, and of course, Louise and Bob Gabriel of the wonderful Santa Monica Historical Society. To Cynni Murphy, supervisor of the image collection at the Santa Monica Library, for all of her help and assistance.

I also wish to graciously thank lifeguard chief Mike Frazer. As this book was being completed, Chief Frazer shared with me that he was able to make a new lifeguard museum a reality. For generations to come, it will allow us to save and preserve the history of the three lifeguard organizations that have served, and continue to serve, the citizens of Los Angeles County.

My deepest gratitude extends to the following: William Doyle and Wendy Stockstill for repairing and shooting many wonderful photographs, and for always being there; Dr. Ronald Love, Elayne Alexander, and Joyce Steers for their work on the manuscript; and Robbie Rodriquez for all his help with all things computer. For photograph production: Herman Hartzell of Hartzell Photography, Marc Wanamaker of Bison Archives, and Tony Sohn of LAX Photo. For photographs: Bill Beebe, Nick Steers, Emerson Gaze, Elayne Alexander, Kim DeBolt, John Olguin, Drew Greger, Tim Morrissey, Steve Wyrostok, Dick and Ester Orr, Bob Sears, Angus Alexander, Tom Thorsen, Jeff Stanton, Larry Cocke, Carrie Darling, Dave Heiser, Doreen North, Dwight Ueda, Milton Slade, William Maguire, Tim McNulty, David Carpenter, Micky Moore, Gordon and Tricia Newman, Matt Lutton, Joel Gitelson, Conrad Liberty, Phil Navarro, Ian Hartunian, Shannon Leavitt, Greg Patterson of the Beach Club, Mr. and Mrs. Steve Harbison on behalf of the Tom Zahn Estate, and the families of lifeguards Bob Butt, Pete Peterson, and Art Cole.

For their friendship and professional support in all my academic endeavors, I wish to thank my longtime teaching colleague, Dr. Thom Armstrong, and my mentor and writing partner, Dr. Andrew Rolle. I am especially indebted to Dr. Gloria Miranda not only for being the best dean in the world but also for her friendship and for all that she has done on my behalf.

For always being there in good times and bad—thanks to all of the Verge family (especially my parents, Art and Margie Verge), Phil and Cindee Topar, Dr. Paul Toffel, Julie Acevedo, Tracy Gaydos, Marjolijn Stolk, and to all of my lifeguard buddies, especially Mark Samet, the guy who always made me and everyone else laugh.

INTRODUCTION

In one of those strange ironies of history, the Santa Monica Lifeguard Service formally began operations at the height of the Great Depression. Despite massive budget cutting at all levels of government, in 1932, Santa Monica's political leaders believed it was imperative to fund a professional lifeguard service. Driving their efforts was their desire to protect the record numbers of visitors who came to the city's beach seeking solace and perhaps a bit of "fun in the sun" during one of the most difficult periods in American history. Santa Monica Beach, as it does now, gave those who needed a place to get away from it all a little piece of paradise.

Even before the difficult Depression years of the 1930s, Santa Monica Beach was a favorite of Angelenos and tourists alike. The palisades above the northern end of the beach were particularly attractive given its stunning picturesque view of the Pacific Ocean. On the southern end of the city, visitors could easily walk down the sand and take a leisurely stroll.

The popularity of the Santa Monica shoreline was not lost on the city's founders and early real estate promoters. Hotels, paved roads, and rail lines were all in place by the late 1880s, encouraging potential land buyers and visitors to come to the city. With the added amenity of a near perfect climate, real estate boosters joked that all they had to do to was to "sell the weather and throw the land in for free."

By the beginning of the 20th century, Santa Monica was a thriving tourist and business hub with the beach as its centerpiece. Problematic, however, was that the ocean, so attractive from afar, proved dangerous to all who entered it. A perusal of the city's leading newspaper, the *Daily Outlook*, finds numerous front-page stories detailing tragic drownings or near-death rescues. Headlines such as "Woman Perishes Before Her Family's Eyes" or "Man Saved From a Watery Grave" hindered the efforts of the region's boosters, who thought the scenic coastline would prove a key selling point for future investment.

Among the ways community leaders tried to get around the issue of drownings was to encourage bathers to swim in plunges adjacent to the beach. Santa Monica's North Beach Bath House advertised that swimmers could safely enjoy the Pacific Ocean by taking their "dips" in the protected confines of their large "breaker free" saltwater pool. Those who ignored posted warnings on the beach risked swimming among dangerous waves and currents. Adding to the danger was the fact that bathers wore cumbersome woolen swimsuits, which became very heavy upon contact with the water. To better protect these venturesome souls, the city installed lifelines along the more crowded areas of the beach. A lifeline consisted of a long rope attached to a buoy out in the ocean and to a post on shore. Bathers were instructed to hold the rope tightly when they felt a current pulling them out or when a large wave was headed their way. Unfortunately, for many, the rip currents proved too strong or the waves too powerful.

These well-publicized losses of life hurt the local coastal tourist and real estate industries. Abbot Kinney, whose neighboring "Venice-of-America" was particularly dependent on tourist dollars and home sales, took the lead in organizing a trained lifeguard force. His efforts met success with the fortuitous 1907 arrival of a young Hawaiian by the name of George Freeth. Known as the "King

of the Surfers" in his native Hawaii, Freeth would share and demonstrate his vast knowledge of all things water. A champion competitive swimmer, high diver, and water-polo player, he would teach local volunteer lifesavers a wide array of techniques that later revolutionized ocean lifeguarding along the Southern California coastline.

Among the young men Freeth met while playing water polo and swimming was Ocean Park resident George Washington Watkins. Watkins, who was better known as "Cap," would later become the first chief of the Santa Monica Lifeguard Service. Although Freeth and Watkins were friendly competitors in water sports, they worked together to organize their fellow players into volunteer lifeguards. By 1908, Freeth had the U.S. Venice Volunteer Lifesaving Corps in full operation. Watkins, in turn, worked northward, patrolling the beaches of Santa Monica on horseback and making rescues when needed. When Freeth felt that his work had been accomplished in Venice, he took his expertise southward to Redondo Beach, where he helped Pacific Electric Railway magnate Henry Huntington create the Redondo Beach Volunteer Lifesaving Corps. By 1914, both Freeth and Watkins were well-known lifesavers and established swim instructors.

As Southern California entered the 1920s, the region experienced record population growth. During this boom decade, Angelenos took to their cars and the Pacific Electric Railway to visit area beaches. Taking advantage of the economic boom and popular interest in the ocean, numerous beach clubs were built along the Santa Monica shoreline. Just as with the Ocean Park and Venice Plunges, local swimmers were hired to work as lifeguards. It was through the efforts of Cap Watkins and British-born swim expert and Santa Monica resident Capt. Tom Sheffield that the guards from the plunges and clubs worked together to protect the beach-going public.

It was out of this semblance of a lifeguard force that Santa Monica followed the lead of the Los Angeles City Lifeguard Service and offered these guards a chance to join the city's newly created lifeguard force. When these first Depression-era jobs were offered, many tried out. Again, following the lead of other lifeguard agencies, Santa Monica only hired the fastest swimmers in the once-a-year competitive 1,000-meter ocean swim race.

The history of the Santa Monica Lifeguard Service proved to be a colorful one. Cap Watkins served as its leader until his retirement at 70 years of age in 1955. During his 23-year tenure as head of the lifeguards, Watkins set the tone for his personnel. Lifeguards were not only to be skilled rescuers but also thoroughly oriented in such water activities as rowing, diving, paddling, surfing, and sailing. From the Santa Monica service emerged such legendary surfers as Tom Blake, Pete Peterson, Tom Zahn, Peter Cole, Buzzy Trent, Matt Kivlin, Joe Quigg, as well as world-ranked champions Ricky Grigg and Mike Doyle.

The Santa Monica Lifeguard Service continued to function as a city-operated service until it was formally merged into the Los Angeles County Lifeguard Service on July 1, 1974. The subsequent merger of the Los Angeles City Lifeguard Service into the county fold, exactly one year later, allowed the three agencies to pool their expertise and resources for today's modern lifeguard service. Currently, as a division of the Los Angeles County Fire Department, L.A. County's 750 lifeguards protect 72 miles of Southern California shoreline. In service 24 hours a day, 365 days a year, these men and women make over 10,000 ocean rescues a year. Among the mottos of the crew is, "Everyone goes home—alive."

<div style="text-align: right;">
Arthur C. Verge, Ph.D.
Professor of History
El Camino College
Los Angeles County Lifeguard since 1974
</div>

One

EVERY SWIMMER A LIFESAVER
1905–1919

Few things did more to hurt Santa Monica's burgeoning tourist and real estate industries at the beginning of the 20th century than did newspaper stories detailing drowning deaths along the local coastline. So problematic was the situation that the community's leading newspaper, the *Daily Outlook,* took to calling for immediate action by city officials so that future deaths could be prevented. In an age where the ocean was to be feared and only admired from afar, it was a group of competitive pool swimmers who helped end the growing losses of life.

Playing water polo and swimming against one another in the ornate beachside plunges of Ocean Park and Venice, these skilled water athletes were asked to give of their free time to volunteer as lifeguards along the shoreline. Under the motto "Every swimmer a lifesaver," they began working as lifeguards during crowded beach days.

Supervising the Santa Monica Municipal Volunteer lifeguards in 1916 was well-known swim expert Thomas W. Sheffield. Among the crew were G. P. Fraser, who was captain of the crew, and Otie Carrillo, who was first mate. Jack Henry acted as the secretary-treasurer for the operation, which involved two lifeguard crews—one for the northern section of beach and the other for the south side of the Santa Monica Pier.

Although it would not be until the 1920s and early 1930s that modern lifeguard services would be in place year-round, hundreds of lives were saved by the efforts of these volunteers.

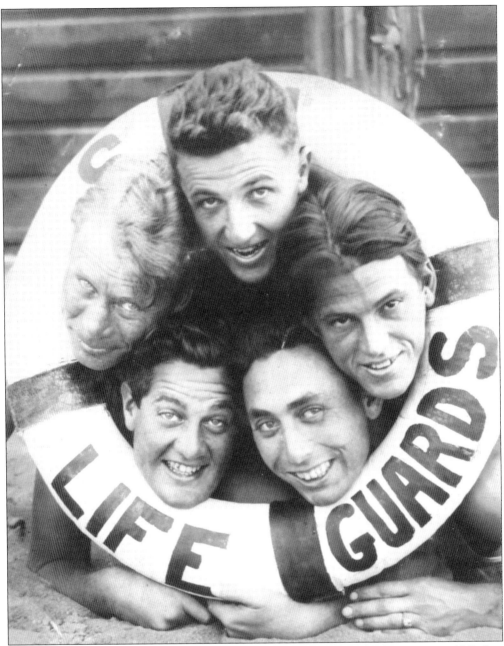

Members of the original Santa Monica volunteer lifeguard crew pose for the camera in 1912. In a time when the sea was feared and avoided by most people, these crewmembers enjoyed the ocean and worked together to save bathers in distress.

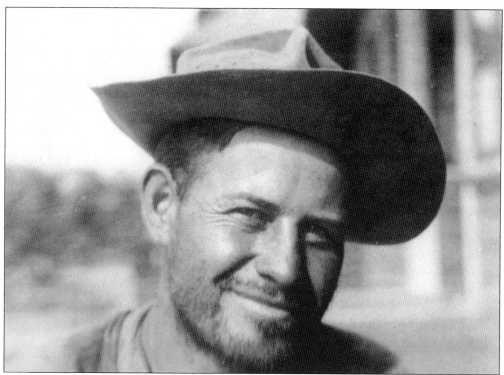

Pictured here in 1913 is Santa Monica's first lifeguard, George Washington Watkins, later captain of their modern service. Better known as "Cap," Watkins first began patrolling the beaches of Santa Monica on horseback in 1905. He made ends meet by working as a stunt double; hence the beard for an upcoming movie.

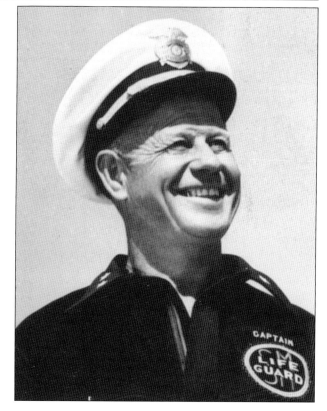

Cap Watkins, known for his genial manner, was a lifeguard on Santa Monica's beaches for over 50 years. As lifeguard chief, he was well liked by his own crew and members of other lifeguard services. Later, reflecting on his half century on the beach and his 23 years as captain of the Santa Monica Lifeguards, he remarked, "While I never made a lot of money, I made a lot of friends."

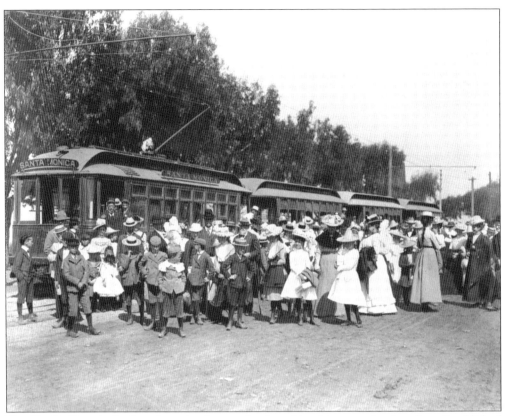

The Pacific Electric Railway brought thousands of weekly visitors to the shoreline. Established by Henry E. Huntington in 1901, the interurban railway would expand to over 1,100 miles of track, allowing Angelinos to travel up and down the Southern California coastline from Santa Monica to Newport Beach.

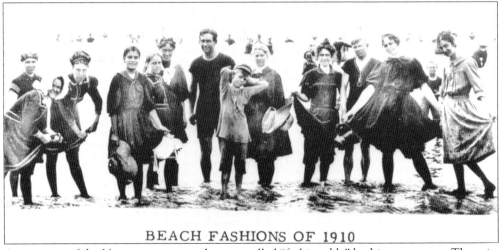

BEACH FASHIONS OF 1910

A carryover of the Victorian era were these so-called "fashionable" bathing costumes. The suits proved to be more deadly than fashionable, as they quickly turned heavy upon contact with water. Sadly, Santa Monica Beach was plagued in its early years by numerous needless deaths among "properly" attired bathers.

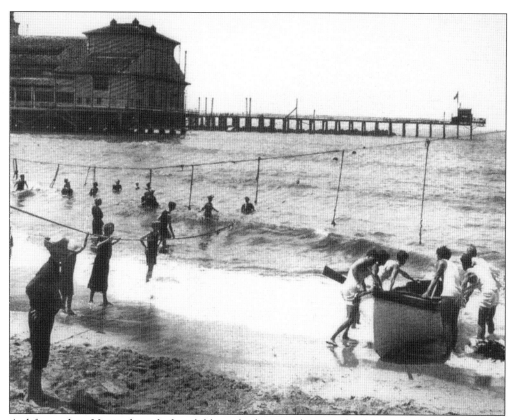

As lifeguards in Venice launch their lifeboat, bathers can be seen clutching one of two lifelines. As early as 1911, fund-raisers were held at local schools to purchase and install the lifelines along the more popular swimming areas of Santa Monica Beach. The lifelines proved deceptively dangerous, however, as strong waves and currents periodically swept unsuspecting bathers out to sea.

With their arms on one another, symbolizing "one for all, and all for one," members of Santa Monica's first volunteer lifeguard crew proudly pose for the camera in 1912.

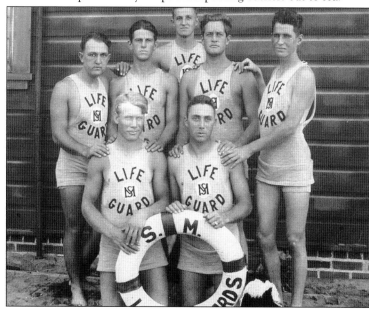

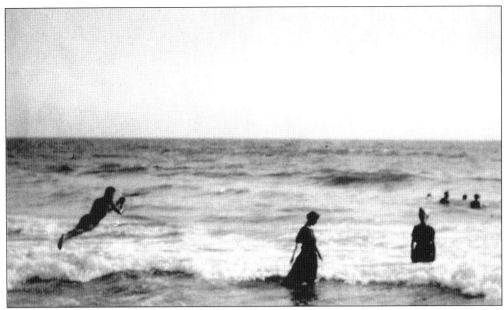

At far left is Cap Watkins doing a perfect racing dive into the ocean in 1913 for the family camera. In 1913, he won the Pacific Coast Championship for diving. He re-created this dive for reporters in 1955, when he learned he was to be forcibly retired from the lifeguard service because he was turning age 70. Watkins complained, "Who dreams up these wacky retirement rules?"

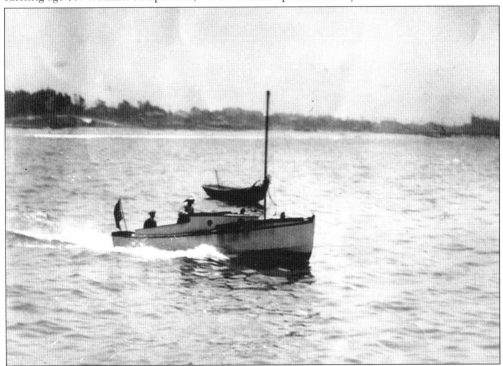

Santa Monica's first lifeguard rescue boat, the *Peggy II*, races out to sea with the American flag flying from the aft. Built in 1913 by Watkins's brother-in-law and fellow Santa Monica volunteer lifeguard, Gus Patzer, the *Peggy II* could reach a top speed of 21 knots.

Hawaiian-born George Freeth was responsible for not only introducing the sport of surfing to Southern California in the summer of 1907 but for being the first to establish modern ocean lifeguard services at both Venice and Redondo Beaches. Freeth and Watkins, friendly competitors, worked together to organize swimmers and water-polo players into volunteer beach lifeguards.

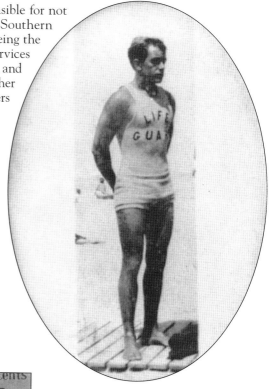

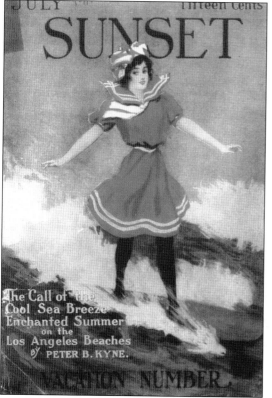

As depicted in this 1911 summer issue of *Sunset Magazine*, the sport of surfing, which had been introduced by lifeguard Freeth only four years earlier, had now caught the public's fancy. The national publication focused on the "scenic and fun" beaches of Los Angeles.

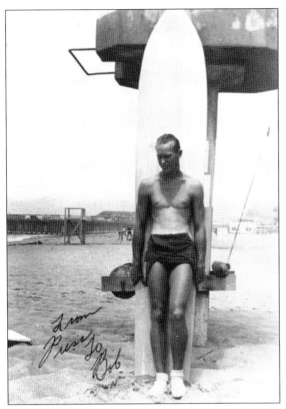

A young Pete Peterson poses with his surfboard on Santa Monica Beach. Peterson followed in Freeth's wake, serving as both an ocean lifeguard and all-around waterman. A champion rower, paddler, and surfer, Peterson represented the best of the Santa Monica Lifeguard Service. He was inducted into the very first class of the International Surfing Hall of Fame in 1966.

A once empty Santa Monica Beach became one of the most popular beaches and tourist sites at the beginning of the 20th century.

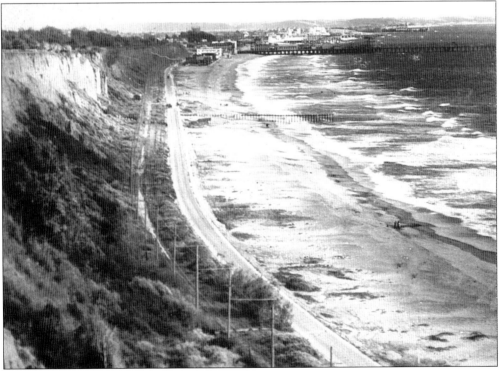

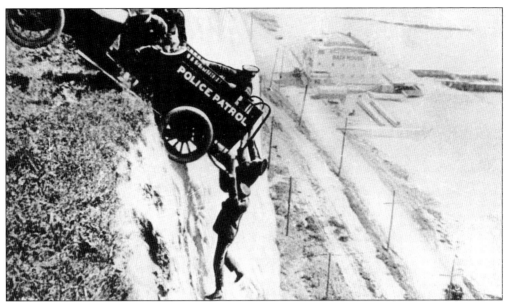

Here Mack Sennett's Keystone Cops perform a dangerous stunt on the palisades overlooking Santa Monica Beach. During the silent-movie era, several of the leading "doubles" (later called stuntmen) were lifeguards.

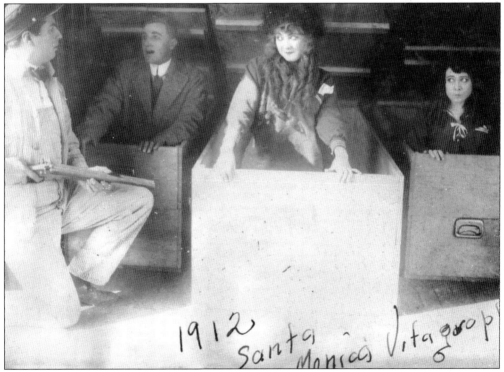

In this rare photograph, Donald Williams Clarke is seen popping out of a box along with his costars in a 1912 Vitagraph production. Clarke, who helped as a volunteer lifeguard on the beaches of Santa Monica, worked a wide variety of jobs at Vitagraph Studios, including stints as an assistant director on numerous silent movies. (Courtesy of Kim DeBolt.)

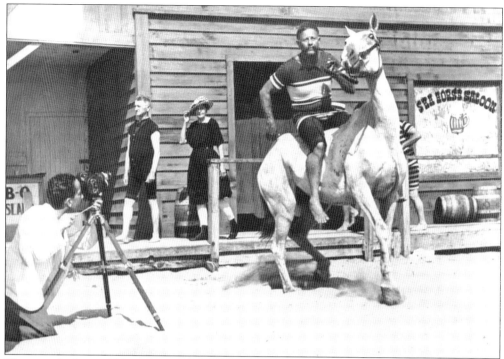

The son of a former U.S. Army scout, Cap Watkins was born in 1885 at Fort Crittenden in what was then the Apache country of Arizona. It was not until Watkins and his family moved to San Diego in 1898 that he first saw and quickly fell in love with the sea. As a skilled horseman, Watkins, pictured here, made ends meet by working as a movie stunt double.

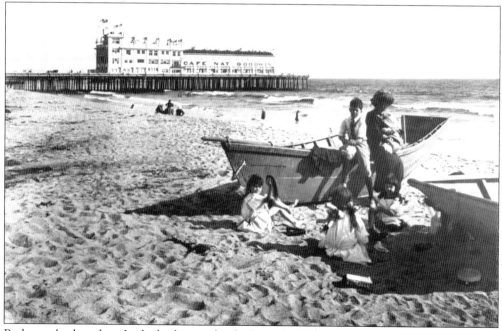

Bathers relax by a dory. In the background is the Bristol Pier that housed Nate Goodwin's popular café. Later called the Crystal Pier, it was located directly west of Hollister Avenue.

Two

AIN'T WE GOT FUN
1920–1929

The beaches, like the surrounding city of Los Angeles, saw tremendous growth during the boom decade of the 1920s. Nowhere was the change more evident along the Southern California coastline than on Santa Monica Beach. The expanse of beach one mile north of the Santa Monica Pier became known as the Gold Coast and was home to several well-known movie stars and studio moguls. The most impressive of the eye-catching dwellings was the Marion Davies estate, built for her by newspaper magnate William Randolph Hearst. South of the pier were several plush beach clubs whose membership included a Who's Who of Los Angeles. Today's popular Casa Del Mar Hotel was one of them.

As Angelenos took to the popular Pacific Electric Railway or their affordable middle-class Ford Model T cars, the beaches of Santa Monica became increasingly crowded. Given the booming economy, volunteer lifeguards became increasingly harder to find. Beach clubs fearing drownings in front of their premises found the solution by hiring and paying lifeguards to protect bathers in front of their respective beach areas. Alarmed that many of the swim areas away from the clubs remained unguarded, Santa Monica officials agreed to pay these guards a few extra dollars a day to help watch over those areas as well.

It was George "Cap" Watkins who helped to put forward the idea that the clubs did not need to have lifeguards whose hours and days varied if the city created its own trained and paid municipal lifeguard force. As the Roaring Twenties neared its conclusion, Watkins's vision came closer to reality.

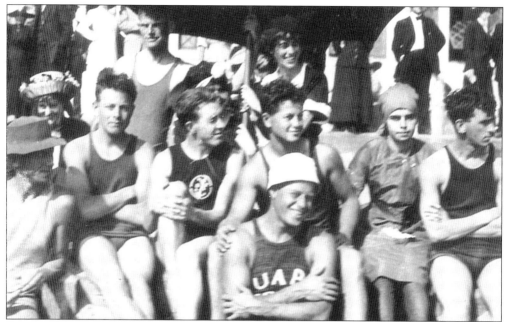
Surrounded by friends, Cap Watkins poses front and center in his lifeguard tank top for the family camera in 1914. (Courtesy of Joan Bacon.)

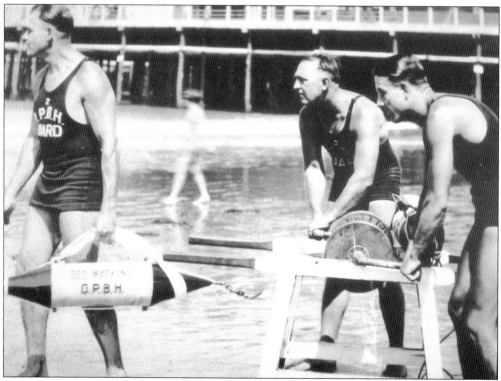
In this 1926 photograph, Watkins is seen with his personalized metal rescue can, marked GEO WATKINS. The O.P.B.H. stands for Ocean Park Bath House, where the three lifeguards worked. The reel was used to pull in the rescuer and victim. The other two lifeguards are unidentified.

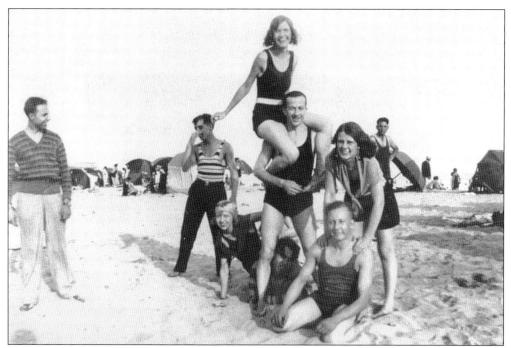

No place better represented the exuberant fun and freedom of the 1920s than the beach. Here beachgoers display some of that "fun." So controversial, however, were women's backless swimsuits that several Santa Monica church leaders complained that "a parade of nakedness" was taking over the local sands.

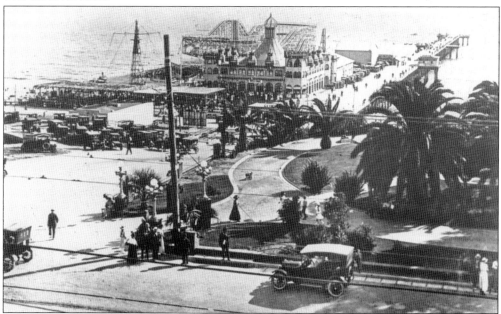

As seen in this 1920s photograph, the Santa Monica Pier was the centerpiece of a growing city and adjacent beach areas. By 1925, the middle-class affordability of Henry Ford's Model T car allowed increasing numbers of weekend drivers to travel from various parts of Southern California to visit the pier and amusement-park amenities. (Courtesy of the Santa Monica Historical Society.)

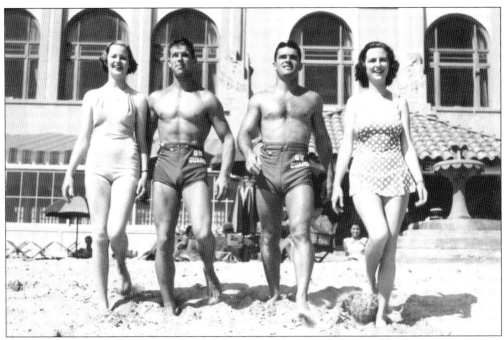

During the 1920s, lifeguards on Santa Monica Beach worked for various hotels, neighboring plunges, and beach clubs. Here two lifeguards from the Grand Hotel on the south side of the Santa Monica Pier walk with two bathing beauties towards the ocean. (Courtesy of the Santa Monica Historical Society.)

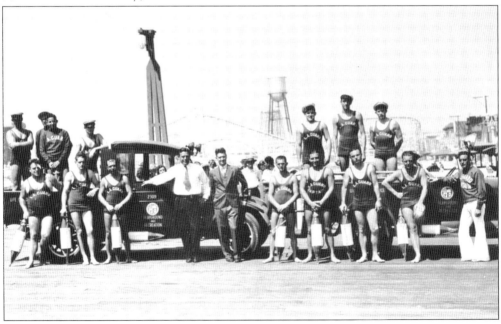

In 1926, the City of Los Angeles put together the first municipal ocean lifeguard service. Here members of the service pose together on the Venice Pier. Both Los Angeles County and Santa Monica would copy the Los Angeles City model when they created their own lifeguard services in 1929 and 1932 respectively.

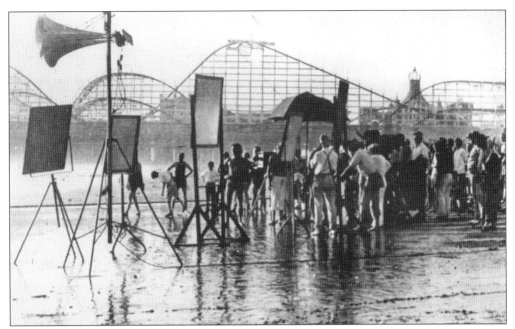

From the movie industry's early days, Santa Monica Beach was a popular location site for filmmakers. Here a large crew is at work during the silent-movie era. The building that houses the Santa Monica Pier's famous merry-go-round is visible in the background.

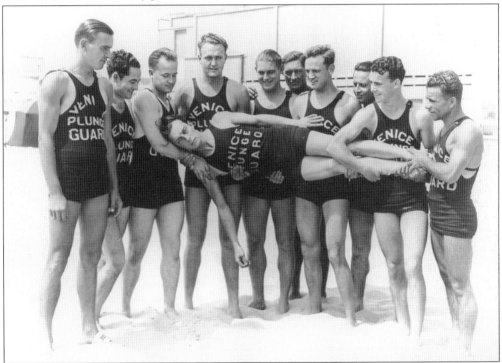

Being held aloft by lifeguards is legendary silent-movie comedian Buster Keaton, who, along with silent screen legends Charlie Chaplin and Harold Lloyd, enjoyed filming at the beach and making friends with the local lifeguards. (Courtesy of Marc Wanamaker and Bison Archives.)

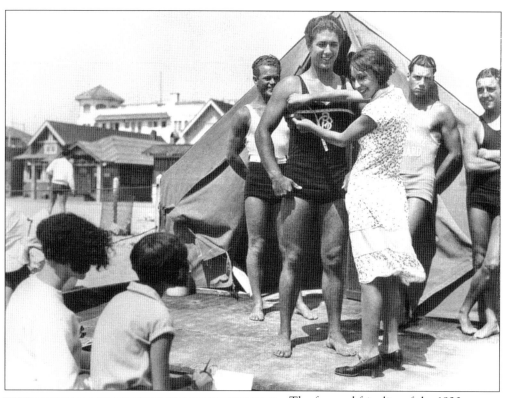

The fun and frivolity of the 1920s is pictured here as local lifeguards participate in a male bathing-beauty contest. Turning the tables on the men are women judges, who are seen writing down the lifeguard's chest measurements.

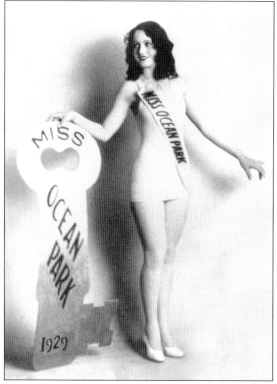

The year 1929 began on an optimistic note, as seen in this January 1929 bathing-beauty photograph, which shows Miss Ocean Park of 1929 (Beatrice Smith) holding an enlarged key to the city. Sadly, the decade of the Roaring Twenties ended with a crash, and America and the world slipped into the Great Depression.

Three

Hard Times and Good Times
1930–1945

The deep decline of the American economy following the stock market collapse in October 1929 led many in Santa Monica to believe that the city's future as a tourist and business center was over. But the city's scenic coastline and Mediterranean-like climate continued to attract local visitors and tourists alike. Given the growing numbers of visitors partaking in beach-related activities on the local coastline, civic leaders agreed that a professional lifeguard service needed to be in place by the spring of 1932. Put in charge of organizing and running the new lifeguard service was the popular and well-known Cap Watkins.

As he took charge, Watkins had the advantage of putting the lifeguard service together when unemployment was at record levels. Able to select among many of the region's fastest swimmers, Watkins focused on hiring lifeguards who were also good with the public. His careful selection of lifeguards enabled the Santa Monica Lifeguard Service to establish a strong rapport with those they served, including the family of future California governor Earl Warren.

Although much of America suffered greatly during the Depression, many lifeguards enjoyed their time on the beach, surfing, fishing, and diving when they were not on duty. Their halcyon days ended on December 7, 1941. During the war years, the Santa Monica Lifeguard Service learned to make do with a skeleton crew, as most of its members went into military service.

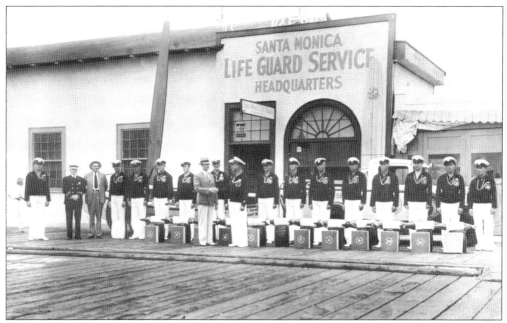

Santa Monica mayor William H. Carter shakes hands with Cap Watkins at the first formal inspection of the new Santa Monica Lifeguard Service crew in 1932. The Santa Monica headquarters pictured in the background is now Rusty's Restaurant on the Santa Monica Pier. Rusty's houses numerous lifeguard artifacts and has played host to several large lifeguard gatherings.

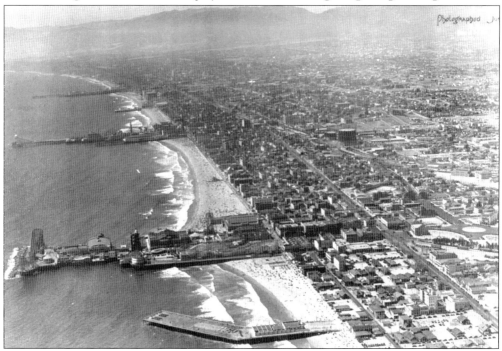

During the 1930s, the Santa Monica Bay was home to several large piers, pictured here in this aerial photograph. From bottom to top, they are the Sunset Pier, the Venice Pier, the Ocean Park Pier, the Crystal Pier, and the Santa Monica Pier.

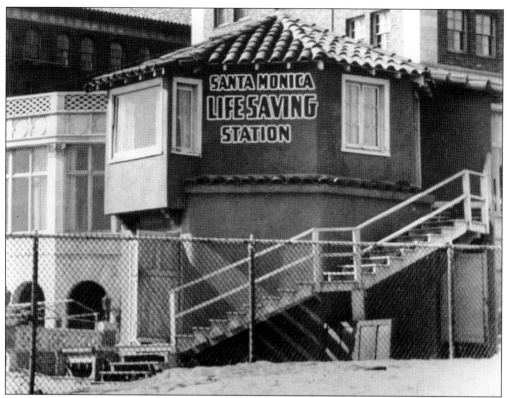

The Santa Monica Lifesaving Station served as the operational center for lifeguards working south of the Santa Monica Pier during the 1930s. The building shared property with today's Casa Del Mar Hotel. In the lean years of the Great Depression, Cap Watkins looked the other way when unemployed lifeguards used the station for winter housing.

Although beach clubs such as the Casa Del Mar thrived during the 1920s, the Depression years proved difficult. To help attract members and paying visitors, the beach clubs encouraged and aided lifeguard operations on their property. Today's Casa Del Mar (immediately left of the Lifesaving Station) plays host to the annual Professional Lifeguard Foundation, which raises scholarship money for Los Angeles County lifeguards attending college.

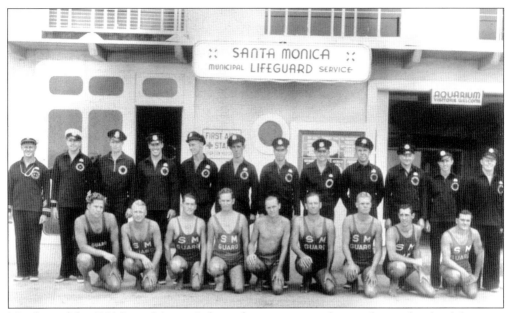

Members of the 1934 Santa Monica Lifeguard crew pose together on the south side of their pier headquarters. The entrance to the pier aquarium, which was maintained by members of the lifeguard service, can be seen to the left.

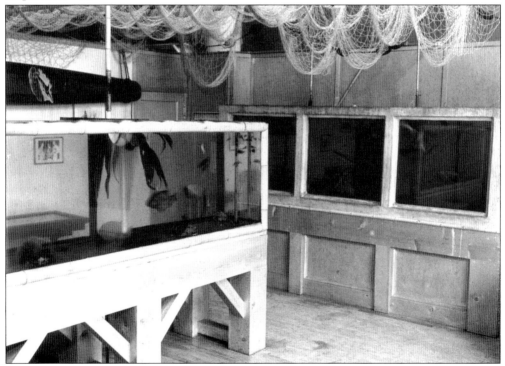

Bob Sears, the last remaining Santa Monica lifeguard from the original 1932 crew, recalls the guards maintaining the pictured tanks and checking their water temperature every four hours. The aquarium also contained a long surfboard donated to Cap Watkins and the crew from Duke Kahanamoku. Duke's board can be seen in the upper left corner of the photograph.

Santa Monica's lifeguards prided themselves on being all-around watermen. Here Cap Watkins takes this lifeboat for a workout.

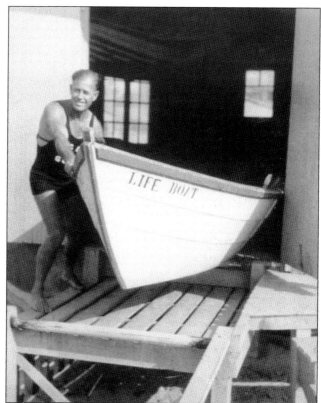

Even with several large wave sets coming in at their backs, renowned waterman Pete Peterson (standing) leads his partner in rowing out for some exercise. Peterson was considered the number one waterman on the West Coast during the 1930s. A four-time winner of the Pacific Coast Surfing Championships during that decade, he ended his celebrated career by winning the tandem division at the 1966 World Championships.

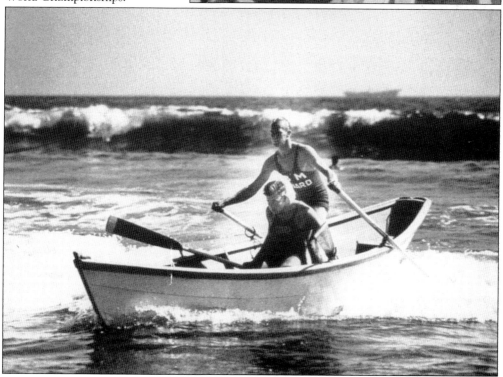

As seen in this Los Angeles Chamber of Commerce photograph, the metal rescue can became a Southern California icon symbolizing the work of the region's ocean lifeguards, though the heavy and bulky metal cans often proved dangerous to rescuer and victim alike.

Pete Peterson put the Santa Monica Lifeguard service on the cutting edge with his invention of the inflatable rubber rescue tube, known as the Peterson Rescue Tube. His invention remains in use today by lifeguard services around the world.

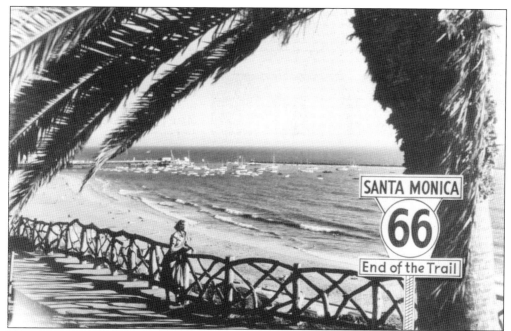

Historic Route 66, also known as the "Mother Road," was the highway route taken during the Great Depression by hundreds of thousands of Midwesterners seeking a better life in California. Originating in Chicago, Illinois, Route 66 passed through Missouri, Kansas, Oklahoma, Texas, New Mexico, Arizona, and ended in Santa Monica. This is what many Dust Bowl refugees saw on their arrival. (Courtesy of the Santa Monica Library Image Archives.)

Despite funding cuts at all levels of government during the Depression, ocean lifeguards were often needed, given that many unsuccessful job seekers went to the shore to get away from the difficulties of the day. The Los Angeles City Lifeguard Service used this tent as a station to meet the growing demand on the Terminal Island beach. Pictured here is L.A. City lifeguard Babe Dillon.

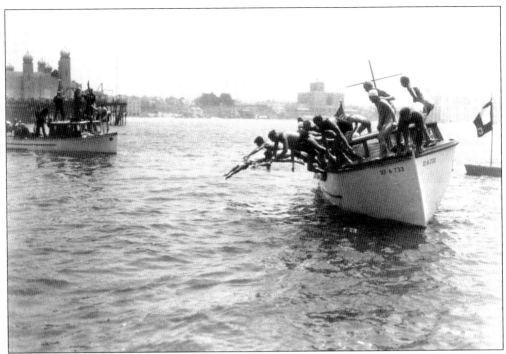

Given the lack of available jobs during Great Depression, employment as an ocean lifeguard was sought by many individuals. In this photograph, those who qualified to take the rigorous one-mile swim race dive off a lifeguard boat to begin the competition.

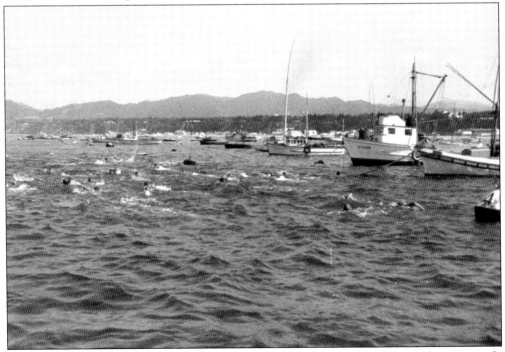

This June 19, 1937, photograph shows the lifeguard test in progress. Out of those who swam, only the top four or five finishers would be selected to join the service.

A candidate for the lifeguard service is fingerprinted as part of the background check process. Every Los Angeles County lifeguard goes through the background check, which can take up to six months to complete.

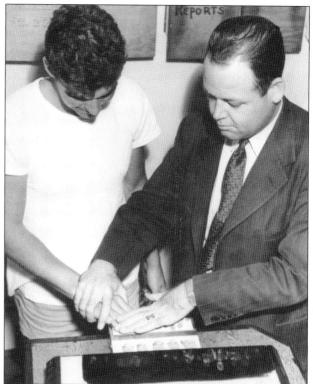

As part of lifeguard training, all equipment had to be learned and used properly. This photograph and outline by lifeguard Bob Sears shows the equipment used by Santa Monica lifeguards in 1938.

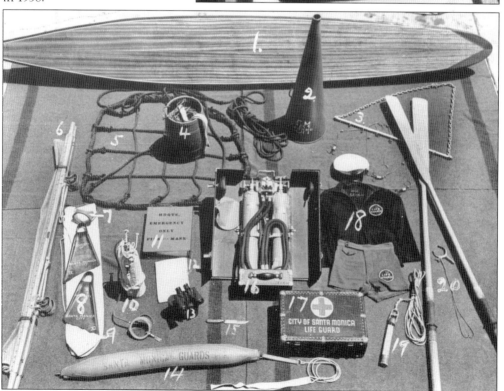

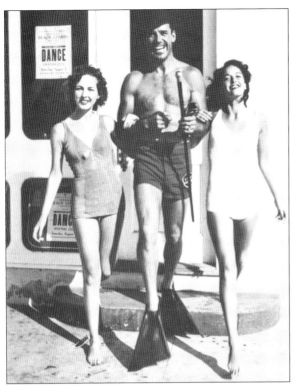

Long before the world-famous television show *Baywatch*, lifeguards were a Southern California icon. Here, escorted by two bathing beauties, Santa Monica lifeguard Bob Butt wears fins and top hat to promote a fund-raising dance for the lifeguard service. (Courtesy of the Santa Monica Library Image Archives.)

Cap Watkins poses with women of the community alongside Santa Monica Lifeguard Service's brand new rescue truck. The truck, which was unable to go on the sand, was stationed on the pier and used to transport those in need of urgent medical care to hospitals. (Courtesy of the Santa Monica Library Image Archives.)

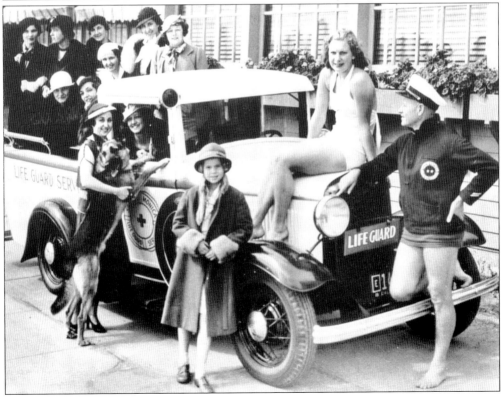

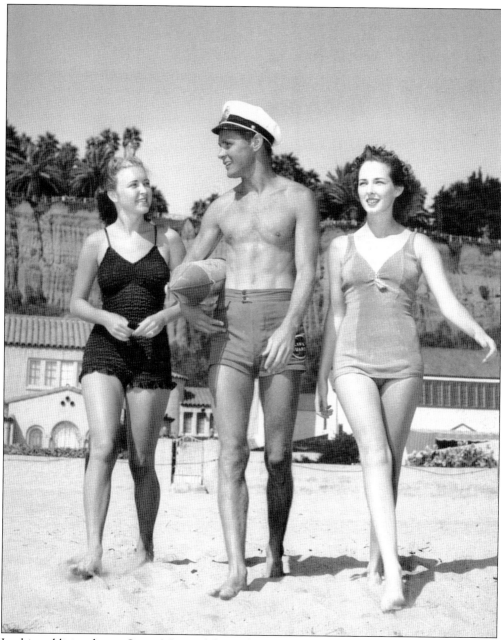
In this publicity shot, a Santa Monica lifeguard, with his metal rescue can at his side, explains the work of the lifeguard service.

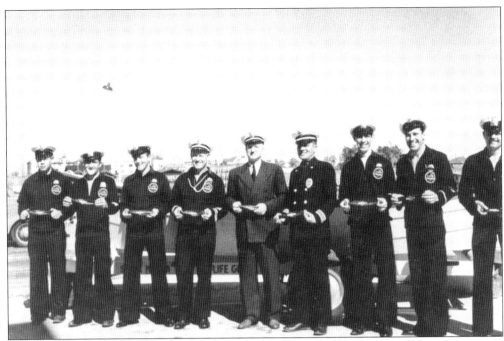

Here, at a promotion ceremony, members of the 1934 Santa Monica Lifeguard Service pose with Cap Watkins and Santa Monica's police and fire chiefs.

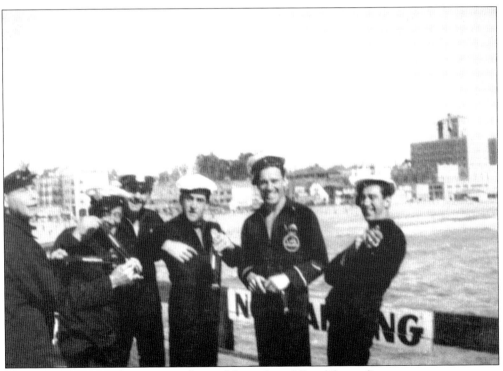

With the brass gone, the same members celebrate for a fellow lifeguard's camera.

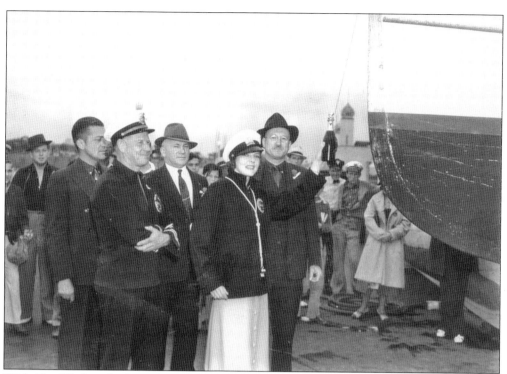

With Cap Watkins looking on, a Hollywood actress prepares to christen Santa Monica's new rescue boat, the *Palama Kai*. It was launched on May 28, 1937.

Here boatbuilders complete a final run-through and inspection before the Santa Monica lifeguards take the *Palama Kai* out on its maiden patrol.

A large crowd assembles to watch Santa Monica lifeguards in a relay swim race in preparation for competitions with other lifeguard services. Despite its relatively small size compared with the Los Angeles County and City Lifeguard Services Santa Monica was known for its excellence in swimming, paddling, and rowing competitions.

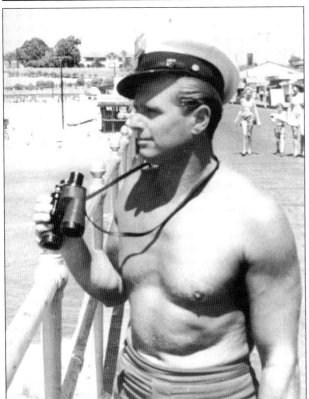

In this publicity shot, a Santa Monica lifeguard is seen watching over the beach from the Santa Monica Pier.

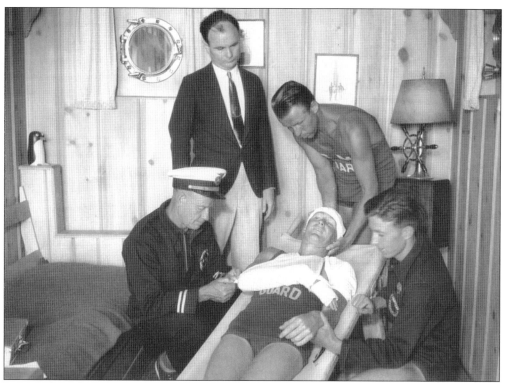

Cap Watkins demonstrates modern first aid techniques.

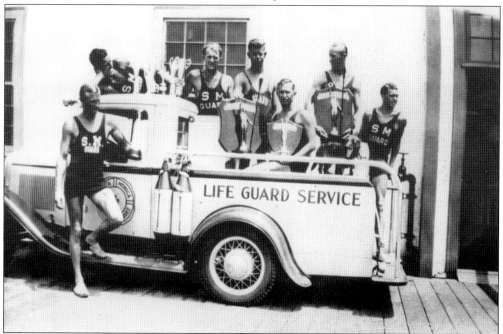

Proudly displaying their trophies and plaques from a recent competition are, from left to right, Chauncey Grantsom, Bob Butt (on roof), unidentified, Billy Watkins, Bill Wadley, Pete Peterson, Scotty (the dog), and Wally Burton.

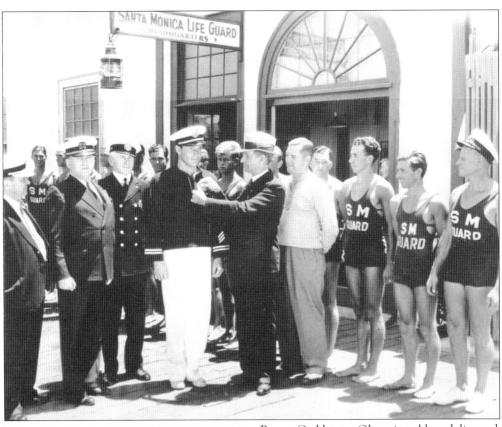

Buster Crabbe, an Olympic gold medalist and Hollywood movie star, is seen being sworn in as an honorary Santa Monica lifeguard. Crabbe often worked out with the crew and saw to it that many guards found work in his movies. He played such roles as Flash Gordon and Buck Rogers.

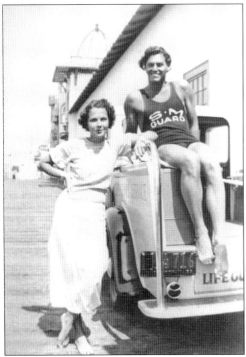

Another popular fixture on the Santa Monica lifeguard crew was fellow honorary guard Johnny Weissmuller. When not acting in movies as Tarzan, Weissmuller enjoyed training with the crew. He is pictured here with a female friend on the service's lifeguard truck.

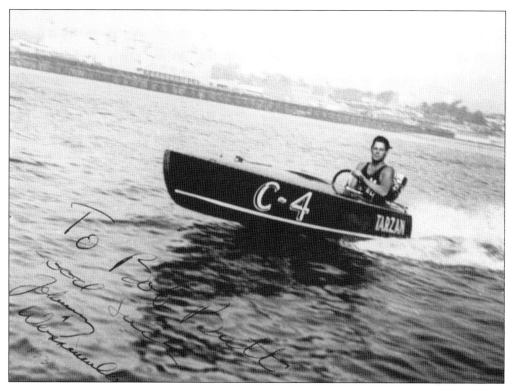

In this 1934 photograph, Weissmuller, in his lifeguard tank top, races his outboard boat. Although most famous as Tarzan, he is also remembered in the sporting world as the greatest swimmer in history. During his seven years of international competition, Weissmuller never lost a race and set the unmatchable feat of 67 world swimming records.

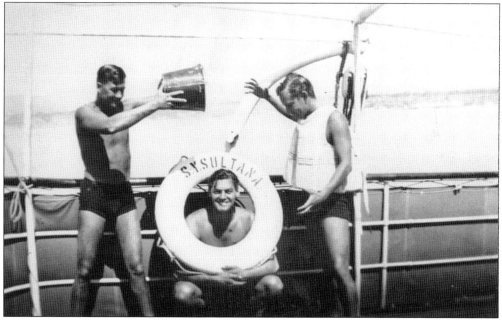

Weissmuller enjoys having fun with two lifeguards aboard the Santa Monica–based yacht *Sultana*.

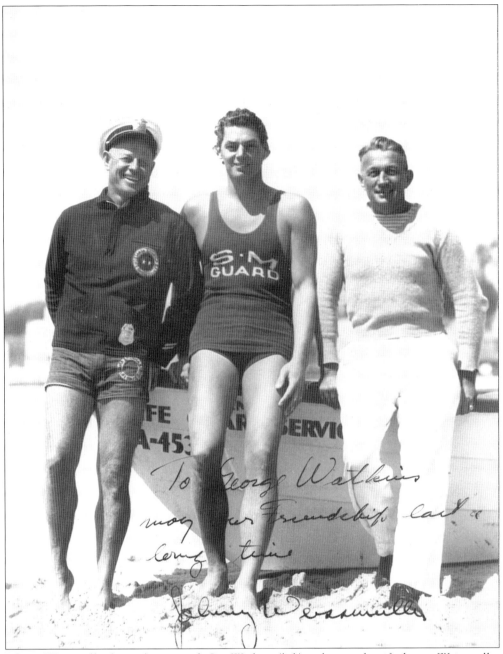

Johnny Weissmuller (center) poses with Cap Watkins (left) and an unidentified man. Weissmuller signed this photograph, "To George Watkins—may our friendship last a long time." His wish was fulfilled, and they remained friends throughout their lifetimes.

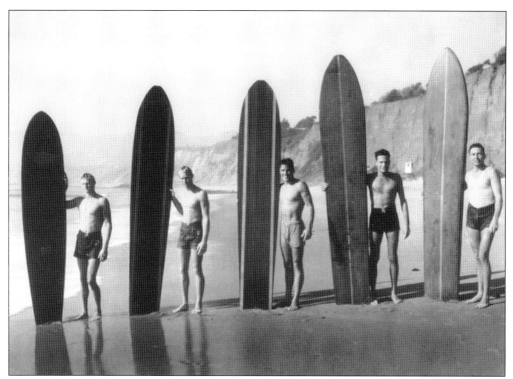

Long before the surfing craze of the 1960s, members of Santa Monica's lifeguard crew were heavily into the sport. Among the early legends from the Santa Monica service were International Surfing Hall of Fame members Pete Peterson and Tom Blake. In 1936, several guards pose before surfing in front of today's Santa Monica Beach Club. Duke Kahanamoku lifeguarded for the club in the 1920s.

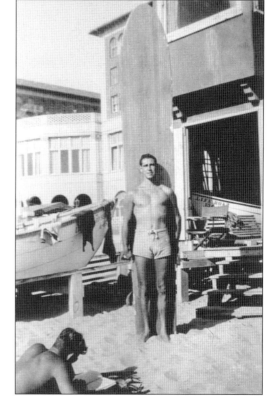

John McMahon poses with his board in front of the Santa Monica Lifesaving Station. Boards, such as McMahon's, often weighed over 150 pounds, necessitating strength and agility to carry them in and out of the water.

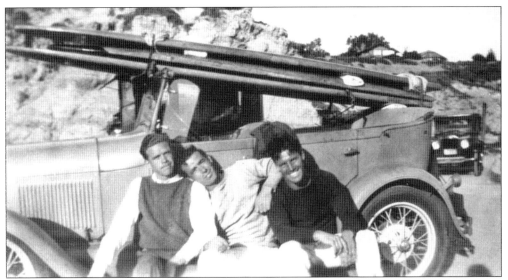

With their boards on top of their "surf roadster," Santa Monica guards Wally Burton (left), John McMahon (center), and Bob Butt pose for the camera. Among their favorite surf spots were Malibu (to the north) and San Onofre (to the south).

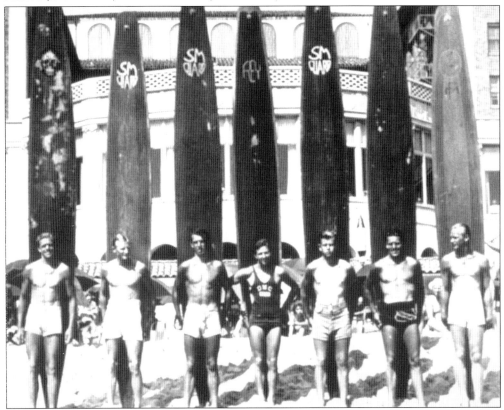

Paddleboard racing was another favorite sport of the Santa Monica lifeguard crew. In this 1934 photograph, members of the service pose with their Tom Blake Hawaiian Paddleboards in front of the Del Mar Club, today's Casa Del Mar Hotel.

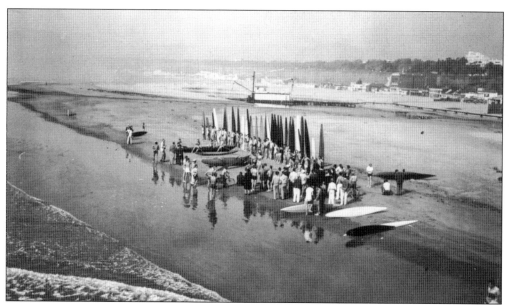

In this 1949 photograph, a large group of paddle-boarding enthusiasts gathers before a race. In the background is a dredging machine on what is today's Santa Monica Tower No. 15 area.

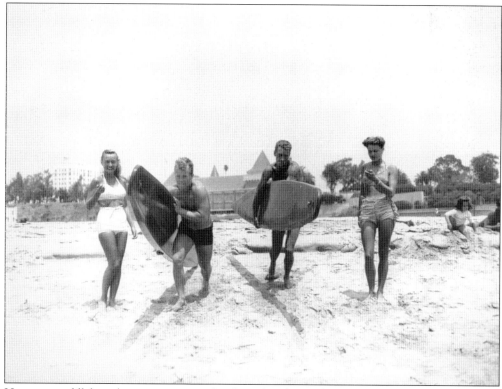

Here two paddleboard racers prepare to battle each other and the clock.

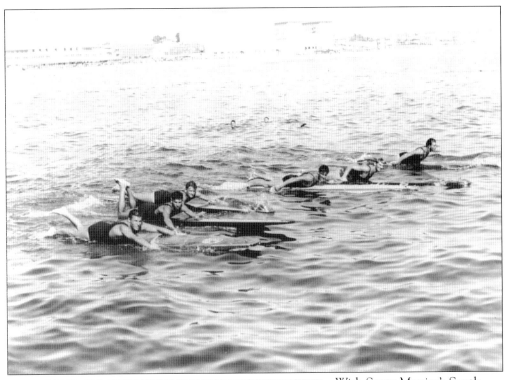

With Santa Monica's South Beach in the background, two Santa Monica guards take a break from a distance swim workout; the remainder of group continues with their paddleboard workout.

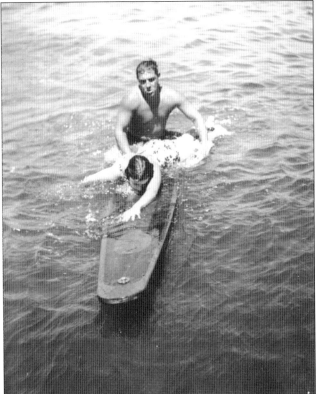

Not only were paddleboards good for working out and racing, but they were also used to make long-distance rescues. Here a guard demonstrates performing a rescue with a paddleboard. Today all Los Angeles County rescue trucks carry a paddleboard for long-distance rescues.

Here Santa Monica lifeguard lieutenant Bill North oversees the launching of one of the service's dories. Although not used to make rescues, dory rowing preserved the tradition of how lifeguards first took to the sea to save those in need.

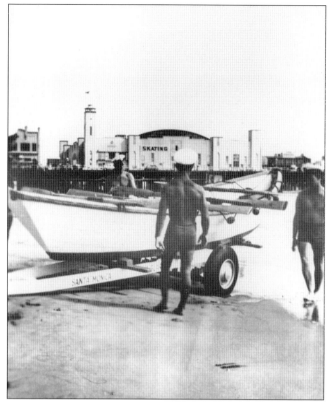

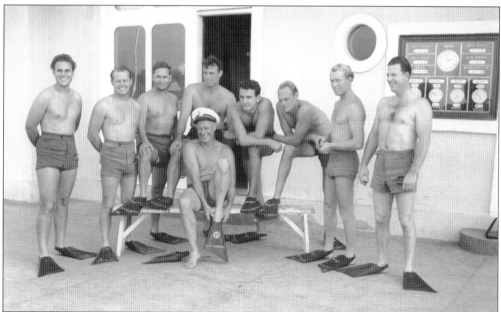

In this 1938 photograph, Cap Watkins joins his crew in putting on newly invented Churchill swim fins. The fins' creator, Owen Churchill, selected the Santa Monica Lifeguard Service to be the first to use them in rescue operations. The fins were later widely used by American UDT (Underwater Demolition Teams) during the Second World War.

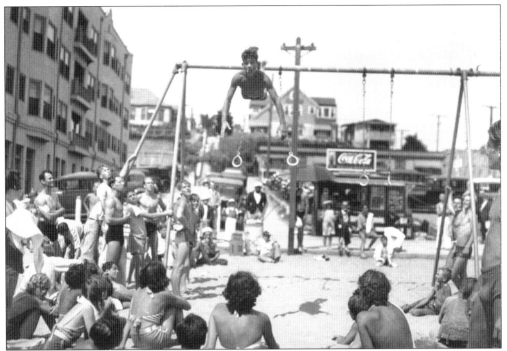

"Flying through the air with the greatest of ease" is one of Santa Monica's Muscle Beach performers. The building on the far left remains standing and is located just south on the boardwalk facing today's Santa Monica lifeguard headquarters. This photograph was taken on September 2, 1936.

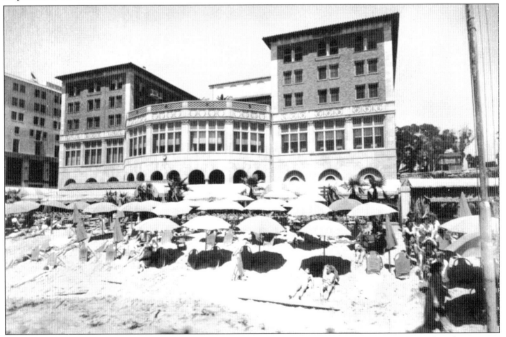

Bathers gather under umbrellas in front of the Del Mar Hotel (today's Casa Del Mar). The scenic beach in front of the hotel washed away during a 1941 storm.

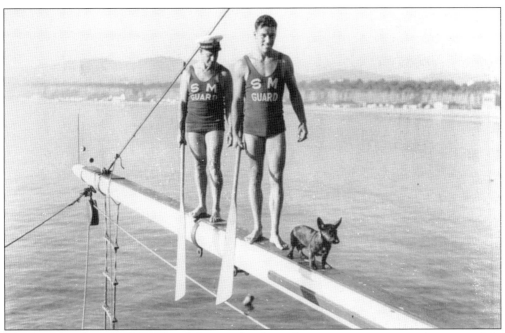

Here Cap Watkins, Bob Butt, and Scotty, the dog, take in a warm autumn afternoon while walking back to the pier atop a rescue boat transom.

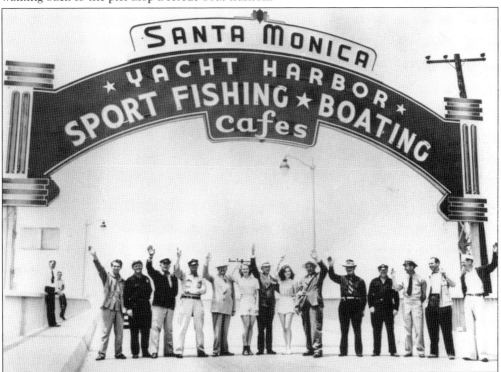

In 1940, members of the Santa Monica Pier Businessmen's Association wave to the camera under their new sign advertising sport fishing, boating, and cafés. Eighth from the left is actress Susan Hayward. (Courtesy of the Santa Monica Library Image Archives.)

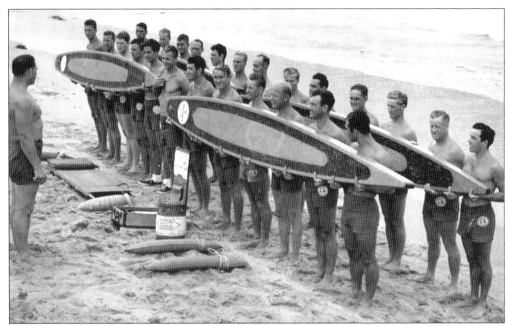

In this June 1941 photograph, the last summer before the onset of America's entrance into the Second World War, Los Angeles City lifeguard chief Myron Cox inspects his Venice Beach crew and their new paddleboards. The paddleboards proved to be too large and unwieldy and were decidedly unpopular with the crew.

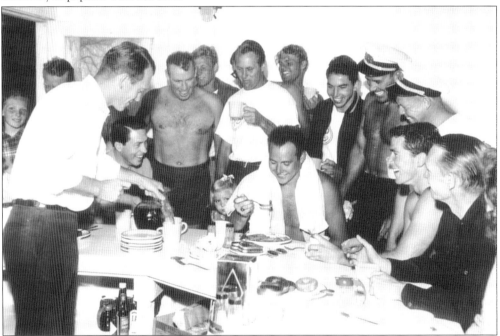

In this May 31, 1941, photograph, Santa Monica lifeguards gather after completing their annual ocean recheck, and the winner of the race happily enjoys a free breakfast courtesy of his fellow crewmates. Sadly, just months later, on December 7, 1941, the attack on Pearl Harbor would forever change the lives of these lifeguards. Nearly all of them served in the war.

Four

FROM WAR TO WEALTH
1945–1960

More than one Santa Monica lifeguard felt his return from the war front to a lifeguard tower "was like going from hell to heaven." Indeed, few places in the postwar world offered a more tranquil and scenic view than did these wooden stations. Returning veterans also brought back with them a strong sense of camaraderie. With their efforts, a new focus on improving the lifeguard organization's standards and equipment became a priority. As a result, the service obtained a faster patrol boat, lighter and faster rescue paddleboards, and updated first-aid equipment. Also of tremendous help was the purchase of two surplus military jeeps. The four-wheel drive "Willy's" enabled Santa Monica's lifeguards to cover large stretches of beach effectively.

The 1950s proved to be a golden decade for Santa Monica lifeguards. The junior-lifeguard program thrived, as did the sport of surfing. Beaches were crowded with locals and visitors alike. Santa Monica lifeguards proved worthy opponents in a wide variety of ocean competitions, earning a reputation as a service whose personnel were all-around watermen. This reputation enabled many of the service's members to find off-duty work as underwater divers and stuntmen in the movie industry. It is hard to imagine today, but many of the lifeguards were able to purchase homes in Santa Monica and neighboring Pacific Palisades. In fact, several guards, including Cap Watkins, went against conventional wisdom and purchased tracts of beachside property in the then unthinkable land of Malibu.

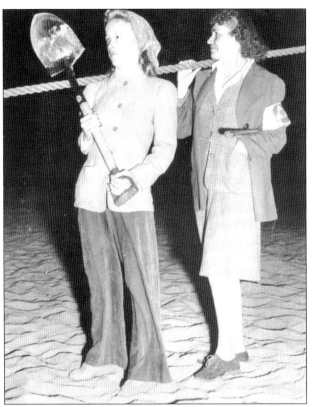

The onset of the Second World War dramatically changed the lives of all Americans. A record 15 million men served in the American armed forces. The loss of millions of men to service overseas opened up jobs on the home front that had been previously closed to women. Here two female volunteers make sure defensive fortifications are in place along a now closed Santa Monica Beach.

In this wartime photograph, Santa Monica lifeguards John McMahon (front) and Fred Bleaker (center) instruct local women in emergency first aid. (Courtesy of the Santa Monica Historical Society.)

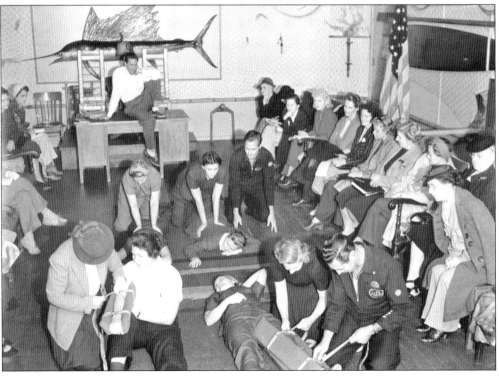

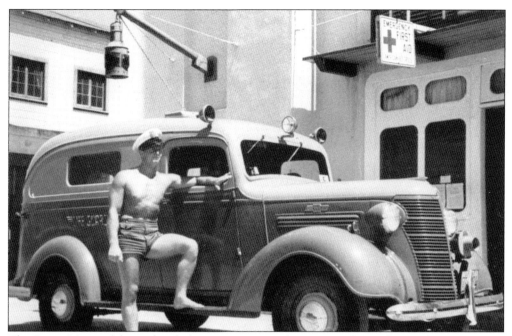

The Santa Monica lifeguard ambulance was exempt from gas rationing during the war. During those years and into the early 1960s, lifeguards were frequently called to respond to medical emergencies inland.

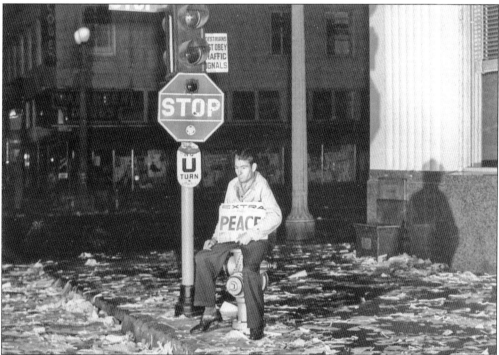

In this poignant photograph by Emerson Gaze, newspaper salesman Ramon Casillas can seen reflecting on the day peace came to Santa Monica—August 14, 1945. The photograph was taken at the northwest corner of Third and Santa Monica Boulevards.

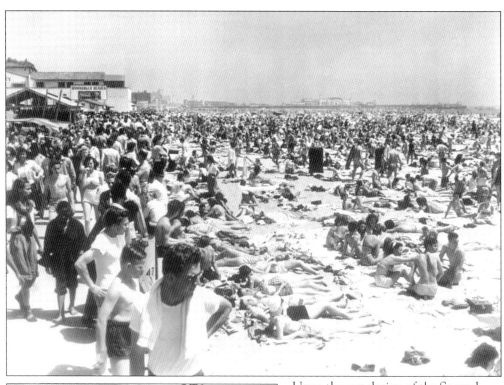

Upon the conclusion of the Second World War, record numbers of beachgoers went to shore as this Memorial Day 1946 photograph attests. This photograph of the crowd was taken one-half mile north of the Santa Monica Pier.

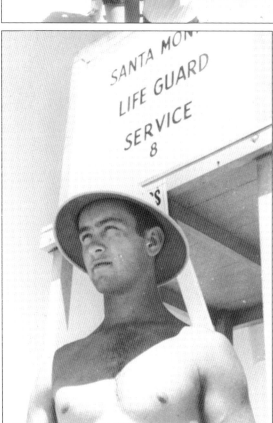

Partially protected from the sun by a pith helmet, a Santa Monica lifeguard looks out over the beach.

In this photograph, Lt. Bill North can be seen standing on one of the original Santa Monica lifeguard stands. In 1932, 12 of these guard stands were placed 400 yards apart along the three and half miles of Santa Monica Beach. Lifeguards derisively referred to them as penalty boxes, given the lack of wind and sun protection.

In 1952, enclosed wooden lifeguard towers replaced the guard stands. The new towers offered not only protection from the elements, but they also proved to be warm in the winter and cool in the summer.

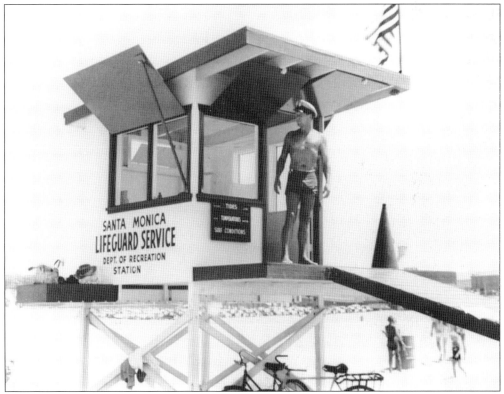

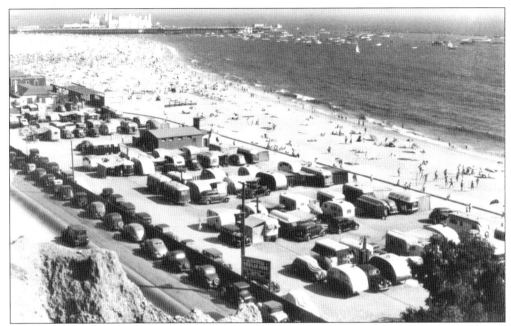

The Miramar Trailer Park was a popular postwar refuge for those who wanted to enjoy the amenities of tent-free camping adjacent to the beach. (Courtesy of the Santa Monica Library Image Archives.)

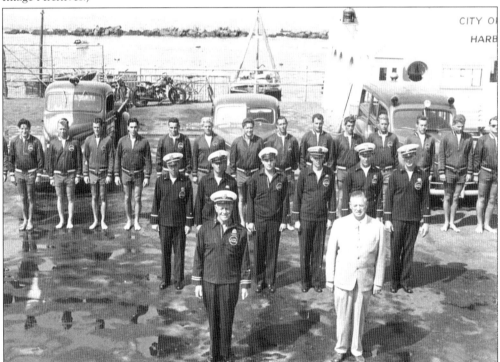

Front and center at the annual Santa Monica crew photograph are Cap Watkins and Frank Holborrow, one of the original volunteer lifeguards who worked with both Watkins and legendary surfer and lifeguard George Freeth.

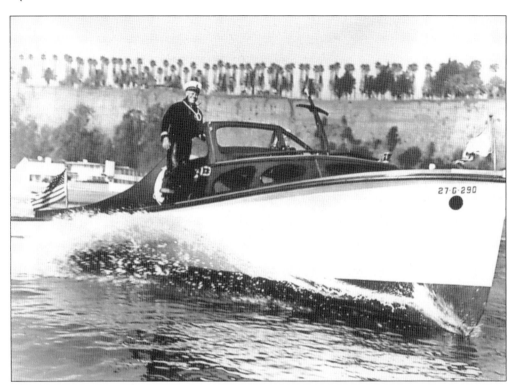

The postwar years saw dramatic increases in civic spending, which included money for a second rescue boat for Santa Monica. Here Cap Watkins can see aboard the new high-speed boat.

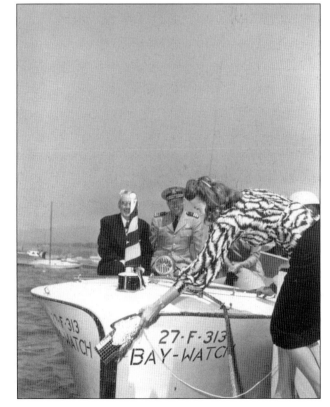

With the Santa Monica Harbor as a backdrop, Los Angeles County's first Baywatch rescue boat was launched on August 21, 1947. The name "Baywatch" was the result of a newspaper contest in which readers were asked to suggest the name for the new county rescue boat.

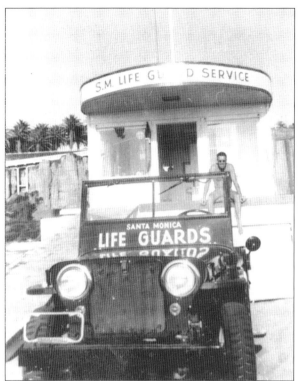

Lifeguard Bob Butt relaxes on the Roadside Rest lifeguard station. Butt did most of the construction of the station. In front is the lifeguard service's reconditioned Second World War Wiley jeep.

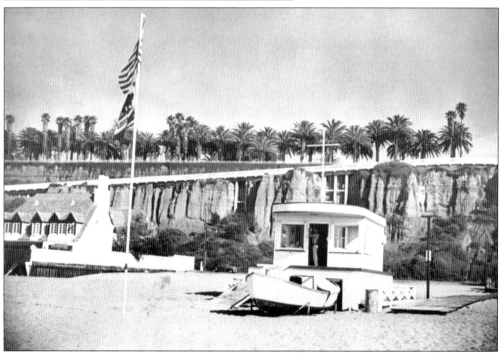

To the north of the Roadside Rest lifeguard station was the home of Cary Grant. The California Incline that leads down to the beach is in the background. The station was torn down in the early 1960s. (Courtesy of the Santa Monica Historical Society.)

Lt. Fred Bleaker displays the lifeguard service's new resuscitator. Such photographs aided the lifeguard service's requests to the city council for getting the latest in medical equipment. (Courtesy of the Santa Monica Historical Society.)

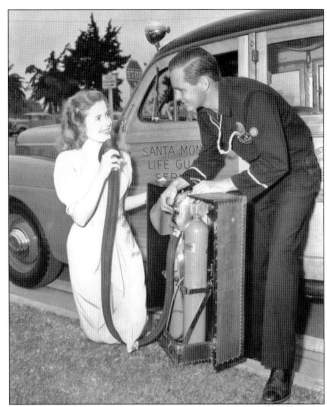

Here Los Angeles County lifeguard Nate Shargo renders first aid to a young beachgoer who has stepped on glass in the sand.

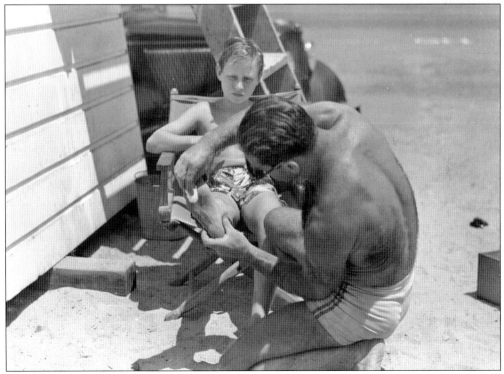

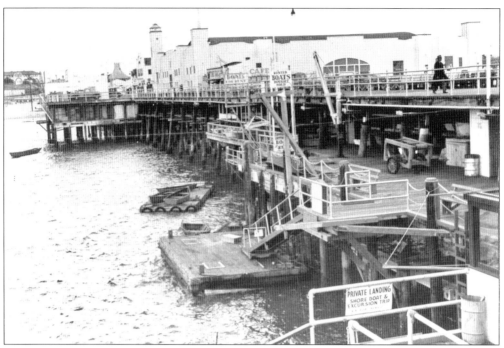

The popular Santa Monica Pier is seen on a quiet morning. Visitors to the pier could rent boats to row around the scenic yacht harbor. In the background is the La Monica Ballroom, where Spade Cooley, "King of Western Swing," performed to packed audiences from 1946 to 1955.

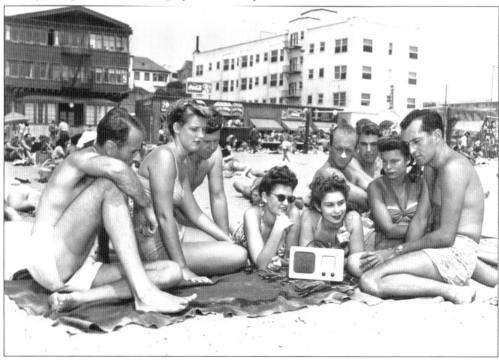

Beachgoers on the south side of Santa Monica Beach listen to news reports of atomic bomb testing on June 30, 1946.

Here Cap Watkins assists in the evacuation of an injured boater. The Santa Monica Lifeguard Service had a boat/first-aid station on the Santa Monica Pier until it was lost in the El Niño storms of January 1983. (Courtesy of the Santa Monica Historical Society.)

In this 1946 photograph, two members of the Manoa Paddleboard Club hit the water on their 14-foot spruce-wood boards. Former Santa Monica lifeguard Tom Blake designed the hollow boards. According to surfing historian Drew Kampion, Blake "almost single-handedly transformed surfing from a primitive Polynesian curiosity into a 20th-century lifestyle."

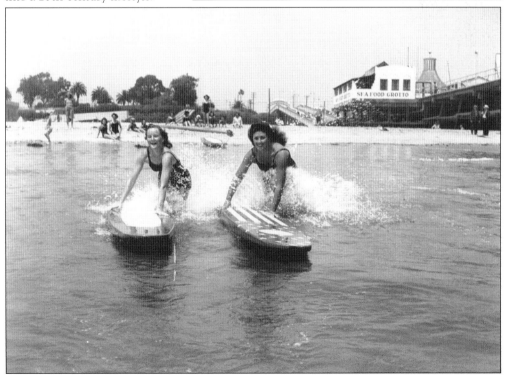

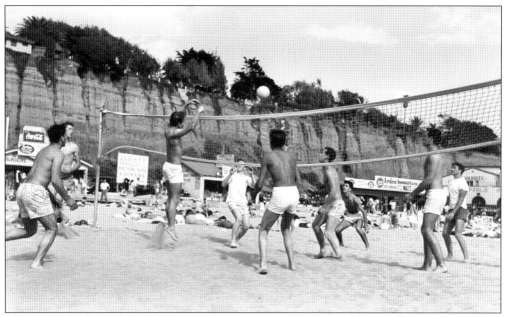

The sport of volleyball was always popular on Santa Monica Beach. Here players enjoy a game in the warm California sunshine in 1946.

With the Great Depression and the Second World War behind them, lifeguards such as L.A. County's Denny O'Brien, seen here enjoying a moment in the sun in front of a fellow lifeguard's camera, had fun working on the beach.

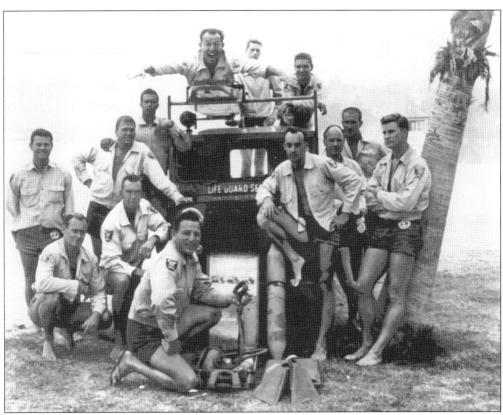

Los Angeles City lifeguard captain John Olguin has his crew gathered around him as he displays the service's new resuscitator. John was awarded the Silver Star during the Second World War, and he helped found today's popular Cabrillo Museum. Above, on the paddleboard, is a crewmember displaying the lifeguard spirit.

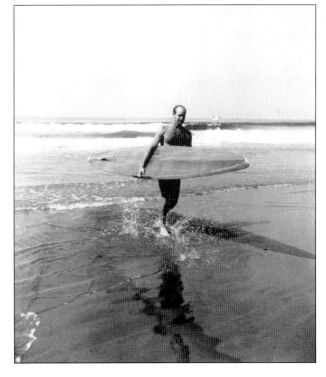

Pete Peterson, a consummate waterman and champion rower and surfer, was a world-class paddler. Here he is seen exiting the water with one of his well-kept boards. According to surf historian Matt Warshaw, "Peterson consistently set and reset paddling marks in all categories from 100-yard sprints to 26-mile open-ocean marathons."

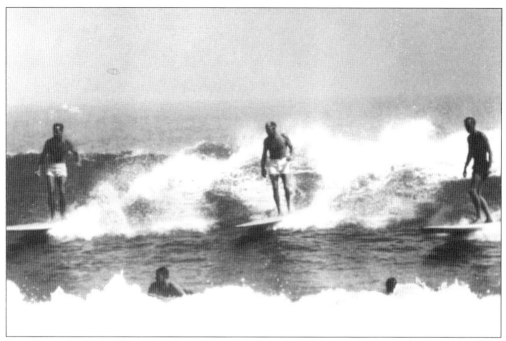

Pete Peterson is seen later in life surfing in the center of the wave. According to one of his contemporaries, Peterson was "muscular and lean, but didn't look like anything special. But when he got in the water, he was the best." (Courtesy of the Santa Monica Beach Club.)

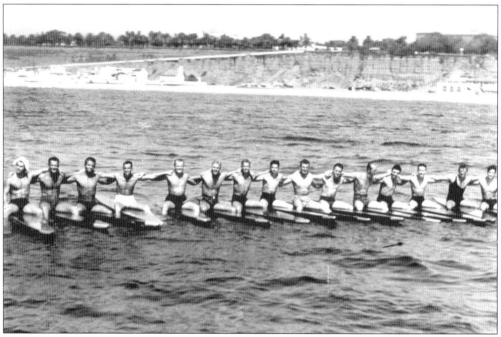

Members of the Santa Monica crew pose aboard their new Pete Peterson–designed paddleboards. Because the local waters were too cold to surf in the winter months, many of the crew spent their winters in Hawaii surfing. Among them were such notable surfers as Tom Blake, Tom Zahn, Peter Cole, Buzzy Trent, Ricky Grigg, Joe Quigg, and Matt Kilvin.

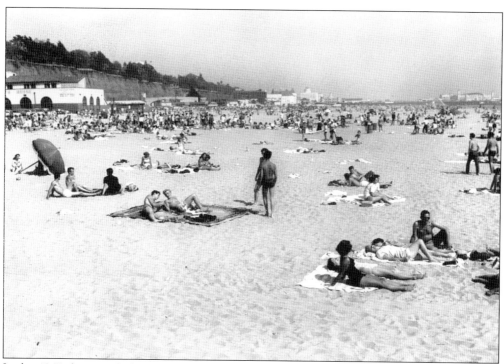

In this 1947 photograph, beachgoers enjoy a late summer afternoon on the sands of Santa Monica's north beach. Today Santa Monica is still divided into the south and north, with the Santa Monica Pier serving as the dividing line.

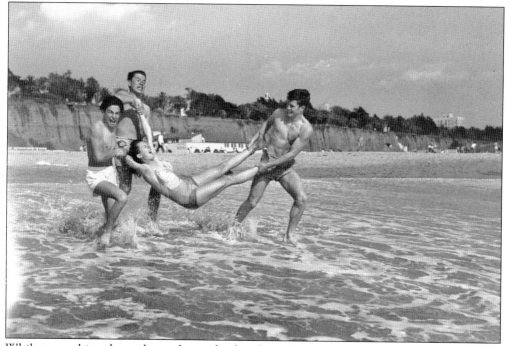

While many things have changed over the decades at Santa Monica Beach, throwing reluctant bathers into the ocean has not.

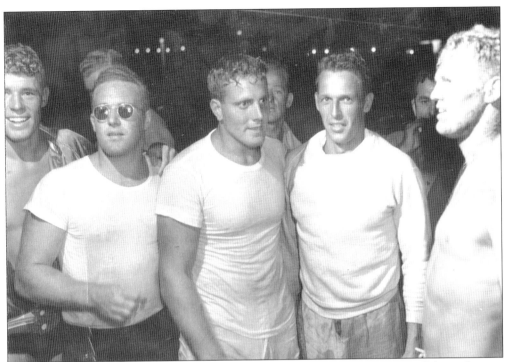

In this photograph titled "Waiting for the Result," a group of Los Angeles County lifeguards waits to find out where they placed in a 1947 evening competition. During the war years, all lifeguard competitions were halted since so many guards were in the military service.

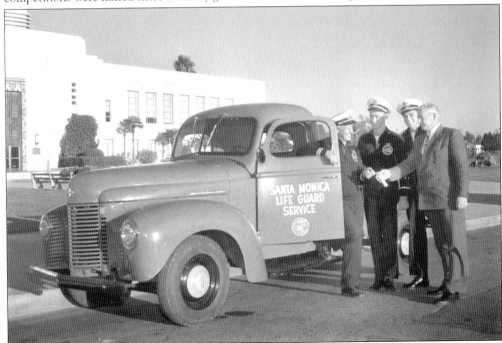

In this photograph, Cap Watkins, accompanied by two fellow lifeguards, receives the keys to a new lifeguard truck in front of Santa Monica's scenic city hall.

Here Watkins is pictured with a model, a city official, and a new lifeguard ambulance.

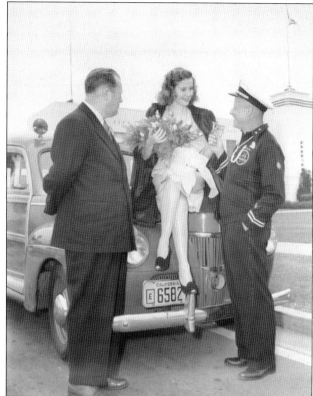

Bob Sears, who turned out to be the longest-surviving member of the original 17-member 1932 Santa Monica crew, steers a Santa Monica rescue boat with two of his children. Bob also served as the crew's photographer and generously donated photographs to the lifeguard archives.

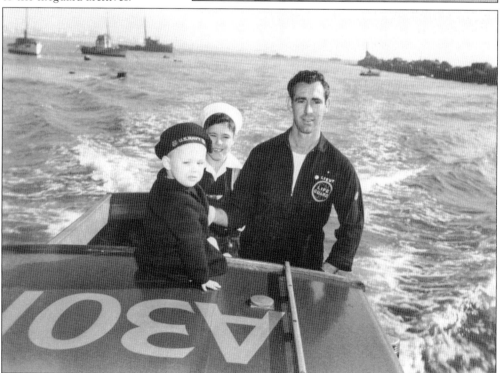

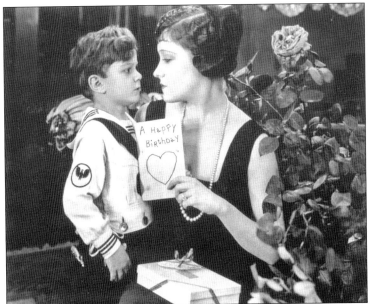

In this 1916 photograph, a young Micky Moore, son of Capt. Tom Sheffield, is pictured acting alongside Gloria Swanson. Sheffield, who worked tirelessly to get the Santa Monica Lifeguard Service formed during the first two decades of the 20th century, encouraged his two sons, Micky and Pat, to get into the then-fledgling movie industry.

Micky Moore, who began his career in the movies as an infant in the original *Ten Commandments*, would have a 90-year plus career in the movies. A second unit director for the likes of Steven Spielberg and George Lucas, Moore worked closely with many of the Santa Monica lifeguards who performed as stuntmen.

Here Micky Moore chats with Santa Monica lifeguard and well-known stuntman Fred Zendar before they shoot an underwater scene. Another lifeguard stuntman and stunt director in the industry was the legendary Paul Stader.

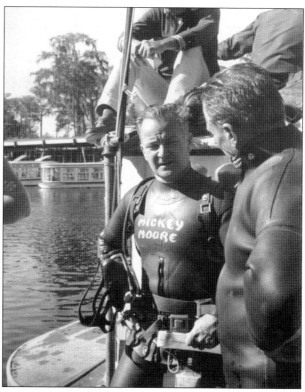

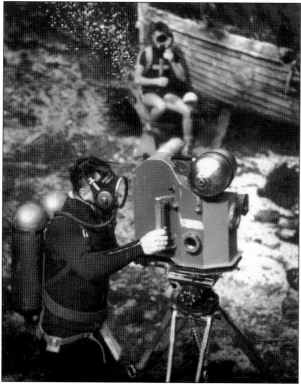

Micky Moore is pictured here at work. In the early days of the movie industry up through the 1960s, many of the underwater stuntmen were lifeguards. Pete Peterson, for example, constantly played the underwater villain in the popular *Sea Hunt* series starring Lloyd Bridges. Peterson joked that the key to his success on the show was that his face was always covered by a mask, thus allowing him never to be identified by viewers.

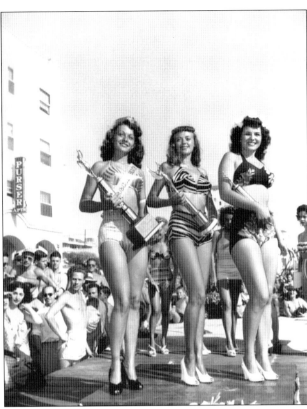

In this photograph, Miss Muscle Beach 1947 has been crowned. Vivian Crockett, the winner, poses with runners-up Val Njord (center) and Jackie McCullah (right.)

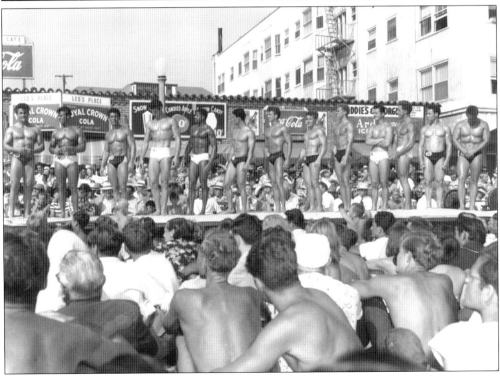

A large crowd gathers to watch the finals of a bodybuilding contest on Muscle Beach in 1947.

The baby boom of the postwar years can be seen in the size of the Santa Monica junior-lifeguard program. Here an instructor teaches the techniques of paddleboard racing. (Courtesy of the Santa Monica Library Image Archives.)

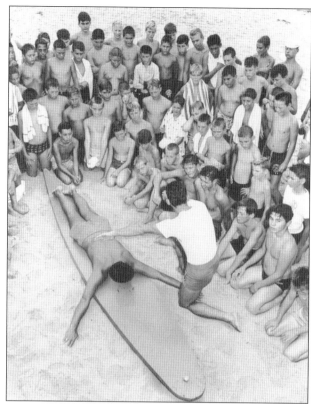

With the Santa Monica Pier to their south, junior guards get ready for a paddleboard relay race. (Courtesy of the Santa Monica Library Image Archives.)

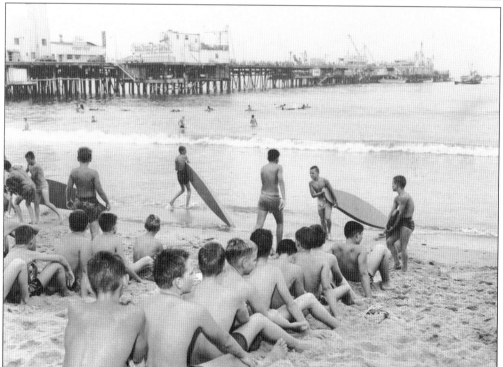

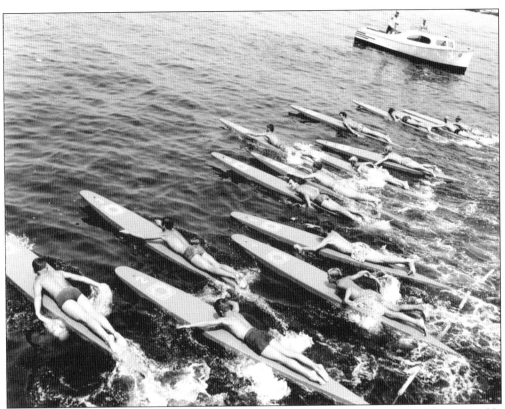

Here the junior guards begin their race through Santa Monica's harbor. A lifeguard boat is visible in the background. (Courtesy of the Santa Monica Library Image Archives.)

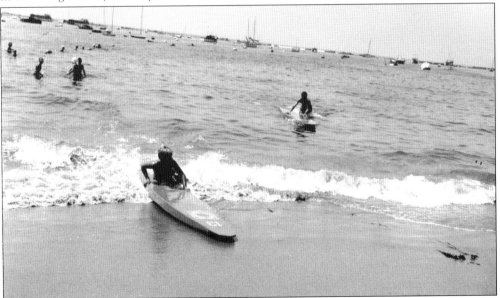

Heading to the finish are two junior-lifeguard paddlers. Several Santa Monica junior guards would make it on to the lifeguard crew and later become champion surfers and paddlers. (Courtesy of the Santa Monica Library Image Archives.)

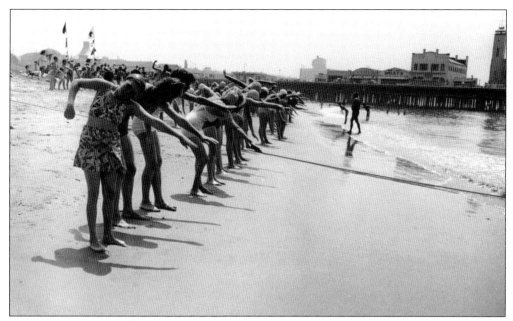

Although the junior-lifeguard program, like the lifeguard service, was restricted to men until 1975, both the Red Cross and the Santa Monica Lifeguard Service taught swimming and water safety classes to women. Interestingly, Cap Watkins proved to be ahead of his time, stating that women should be allowed to become lifeguards. (Courtesy of the Santa Monica Library Image Archives.)

Here young women practice water rescue techniques. In the background, the pier's merry-go-round building is visible. (Courtesy of the Santa Monica Library Image Archives.)

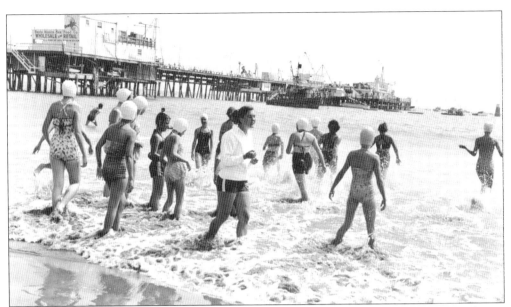

In this photograph, young trainees prepare for an ocean swim. (Courtesy of the Santa Monica Library Image Archives.)

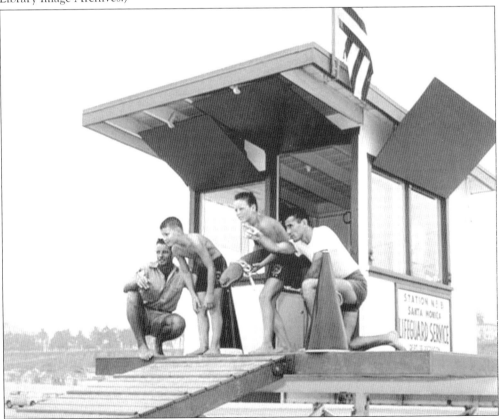

Instructors Rudy Kroon (left) and Frank McMahon (right) prepare two junior lifeguards for a practice rescue.

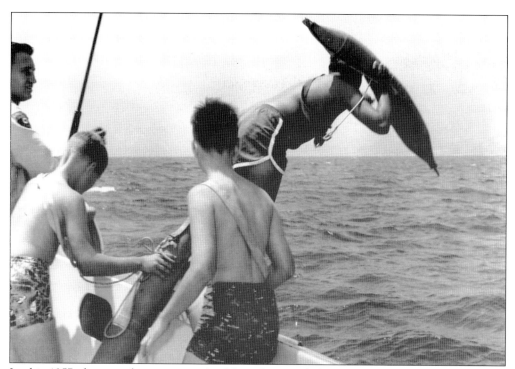

In this 1957 photograph, instructor Art Verge Sr. signals for a junior guard to jump from the lifeguard boat. Diving from a moving lifeguard rescue boat to carry out a practice rescue remains a favorite activity of junior lifeguards.

Considered the most difficult part of training for junior lifeguards and once required of those at the top class level (the A's) is the pier jump. Here lifeguard Art Verge Sr. (standing just above the "outboards" sign) oversees the pier-jump drill. (Courtesy of the Santa Monica Library Image Archives.)

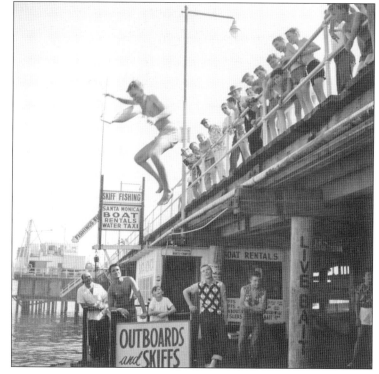

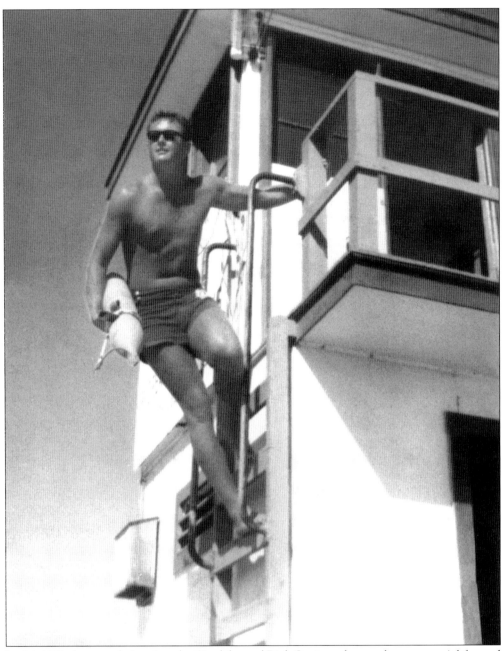
In this 1953 photograph, Los Angeles City lifeguard Dick Orr is ready to make a rescue. A lifeguard for over 50 years, Orr was also a teacher and played professional football for two seasons with the Baltimore Colts.

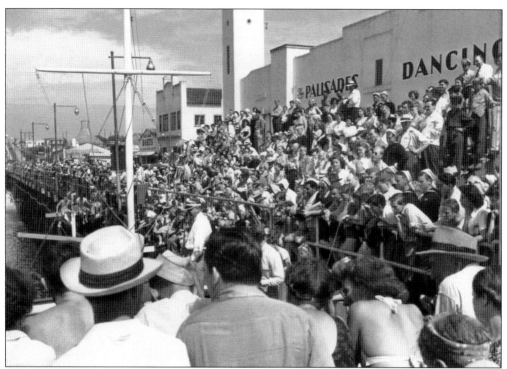

Before the popularity of television, large crowds would turn out to see lifeguards compete in a wide variety of events. Here, in 1946, a crowd gathers to view a lifeguard paddleboard polo match.

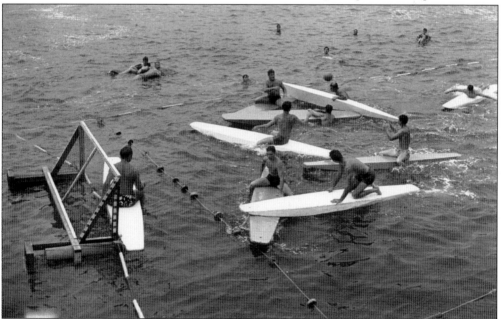

Here members of the Santa Monica Lifeguard Service compete against their Los Angeles City counterparts. The polo matches were later discontinued due to the injuries caused by the heavy wooden boards. The guards, however, continued to compete against one another in rowing, paddling, and swimming contests.

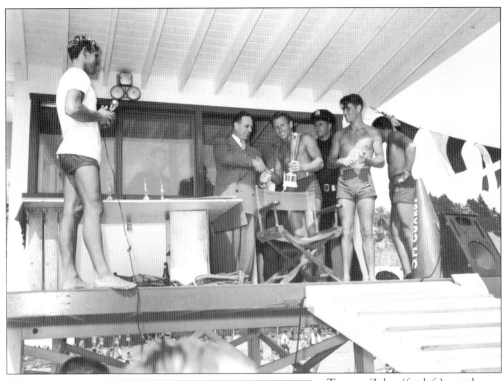

Tommy Zahn (far left) watches as awards are given following a lifeguard ocean race. The races, which continue today, are often held at night on such beaches as Manhattan and Hermosa. (Courtesy of the Santa Monica Library Image Archives.)

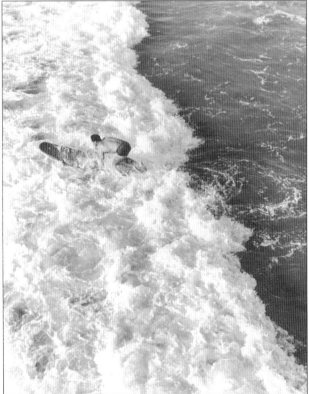

Lifeguard Bob Sears took this photograph of a fellow lifeguard practicing for an upcoming paddleboard race from the Santa Monica Pier.

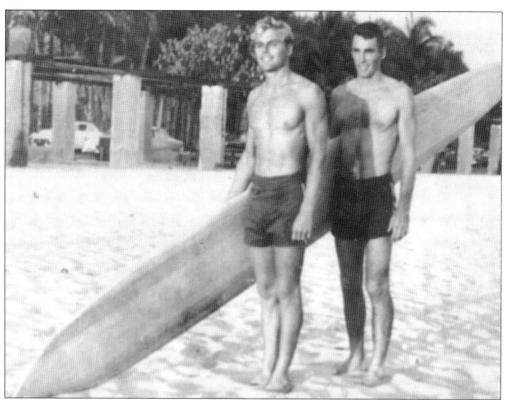

Santa Monica lifeguards and well-known surfers Tom Zahn (left) and Joe Quigg (right) pose with a long board in Hawaii. Quigg designed and made the now famous Darrylin board for Zahn's then girlfriend, Darrylin Zanuck. The very light, all-balsa board became the rage of Malibu and forever changed the design of surfboards.

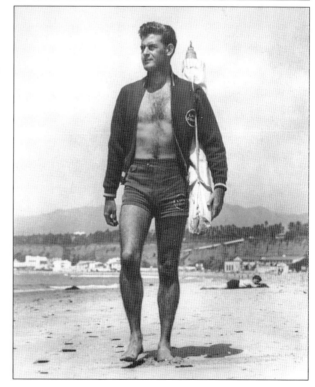

Here a Santa Monica lifeguard patrols the north side of Santa Monica Beach carrying a Pete Peterson–made rescue tube.

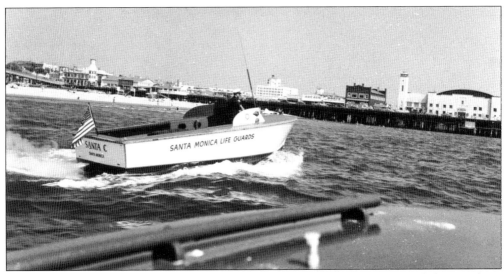

Despite often being underfunded, the Santa Monica Lifeguard Service was careful always to have two rescue boats in service. During large surf with rip currents, one boat was assigned to patrol the south beach while the other was assigned to the beach areas north of the Santa Monica Pier. In this photograph, the second Santa Monica boat can be seen at work.

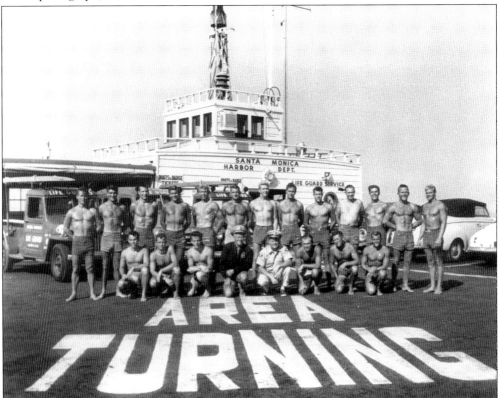

In this 1950s photograph, the Santa Monica lifeguard crew can be seen in front of the old Harbor Department offices at the end of the Santa Monica Pier. The Harbor Department offices, which were above the lifeguard boat station, were destroyed in the 1983 El Niño storms.

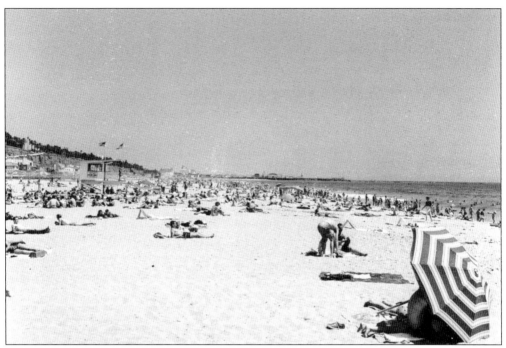
The placement of jetties and groins along the coast above Santa Monica caused the beach to widen. Pictured here during the 1950s is the beach on Santa Monica North during a warm summer day. (Courtesy of the Santa Monica Library Image Archives.)

Santa Monica lifeguard chief Bill Bowen steers the lifeguard service's new rescue boat toward the pier for docking. The boat, christened *Rescue 1*, stayed in service for over two decades and was responsible for assisting in the rescue of thousands of swimmers and boaters. (Courtesy of the Santa Monica Historical Society.)

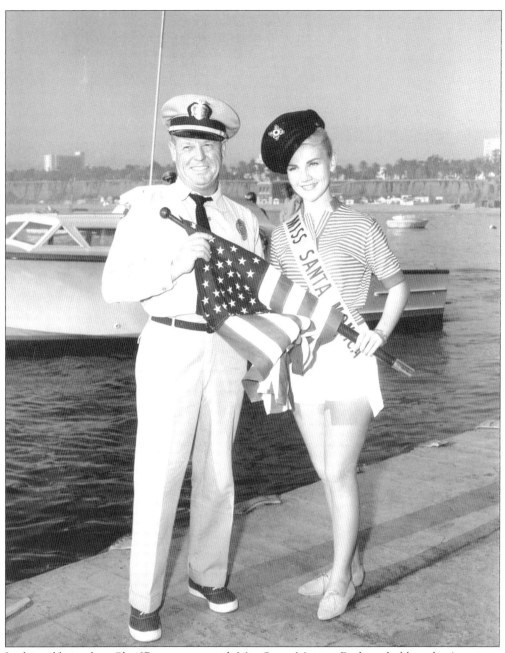
In this publicity shot, Chief Bowen poses with Miss Santa Monica. Both are holding the American flag, which traditionally flew from the aft of the lifeguard boat. (Courtesy of the Santa Monica Historical Society.)

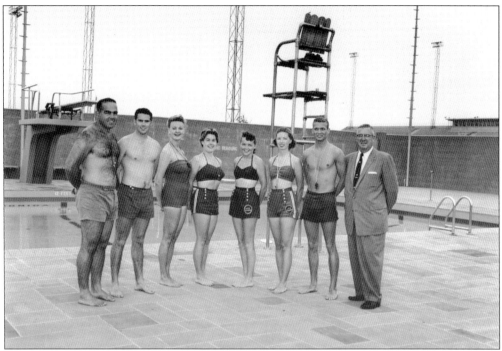

At the far left of this 1952 photograph is Santa Monica College Hall of Fame coach John Joseph. Coach Joseph was responsible for putting more than 300 ocean lifeguards on the lifeguard crew in his 46 years of swim coaching at SMC. (Courtesy of the Santa Monica Library Image Archives.)

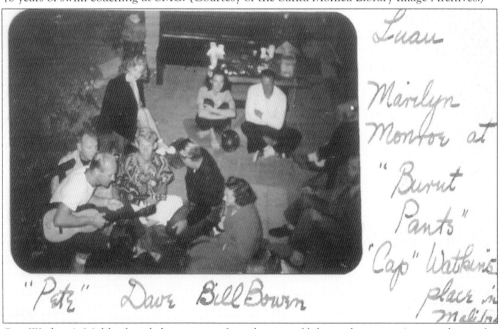

Cap Watkins's Malibu beach home was often the site of lifeguard parties. Among those who enjoyed joining in the evening luaus were such luminaries as Gov. Earl Warren and actors Gary Cooper and Leo Carrillo. Pictured here at one such party is Marilyn Monroe, who dated Santa Monica lifeguard Tom Zahn.

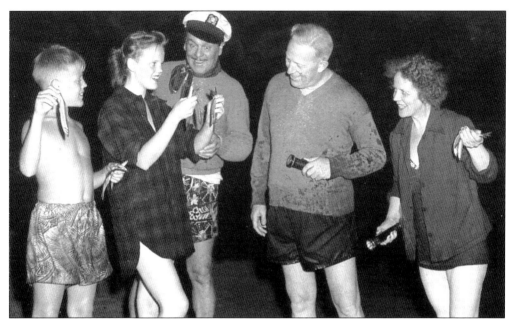

Enjoying an evening grunion run are actor Leo Carrillo (with hat) and members of Gov. Earl Warren's family. Governor Warren, seen holding flashlight, would later become chief justice of the United States. Cap Watkins was one Warren's closest friends.

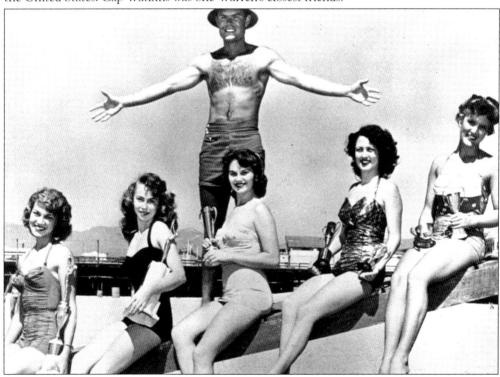

Santa Monica lifeguard Bob Walthour enjoys the company of five beauty contestants—all sitting on his lifeguard station ramp. This photograph was later used in the closing credits of the hit television show *Baywatch*.

Five

SURF CITY—
HERE WE ARE
1961–1973

The beaches of Southern California have always been known as the epicenter from which the popularity of surfing emanated. Given the proximity to both the movie and music industries, it was not surprising that the scenic coastal region acquired worldwide attention for its attachment to the sport beginning in the early years of the 20th century. It was not until the mid-1960s, however, that participants and fans recognized the need to acknowledge the early pioneer surfers who made the sport a global phenomenon.

The Santa Monica Civic Auditorium was home to the first two International Surfing Hall of Fame Award ceremonies. It proved to be a perfect venue. Host to the Academy Awards from 1961 to 1968, the civic auditorium was just up the street from the very beach where many of the legendary pioneer surfers had begun their careers. Attracting an audience of over 2,000, the first ceremony in 1966 saw 11 members inducted into the Hall of Fame, three of whom (Pete Peterson, Buzzy Trent, and Mike Doyle) were Santa Monica lifeguards. The next year, fellow Santa Monica lifeguard Tom Blake was inducted.

Without question, no service in history had more impact on the sport of surfing than did Santa Monica. In fact, the most famous surfer in history, Duke Kahanamoku, worked as a lifeguard at the Santa Monica Beach Club in the 1920s. There he enjoyed and retained throughout his life many friendships with members of the Santa Monica lifeguard crew.

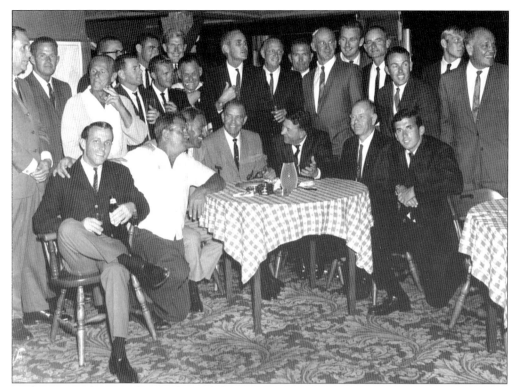

In this 1960s photograph, members of the Santa Monica lifeguard crew and alumni gather at the old Malibu Sea Lion restaurant. Note that the crew is all male and almost all are formally dressed in coats and ties. At today's lifeguard gatherings, popular Hawaiian attire is *de rigueur* unless dress uniform is required.

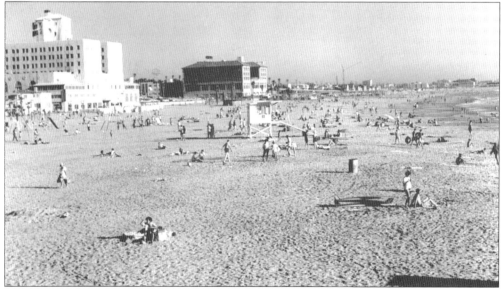

This photograph looks southward from the Santa Monica Pier to Santa Monica Beach. Pictured in the far background is a large crane used for in the construction of the Santa Monica apartment towers.

Lifeguard Lawrence Schnabel is pictured with his girlfriend, Molly Botkin, a competitive swimmer and gold medalist in the 1960 Olympics. She and Schnabel, who swam for Stanford University, would race during workouts in the ocean. Invariably Botkin would win—and at a time when women were not allowed to become lifeguards.

Santa Monica lifeguards Don Grieb (left) and Gene Poole smile for the camera in this 1960s photograph. Note the large-nosed surfboard and the wide, rubber rescue tubes. The large station that they are standing on was replaced in 2003.

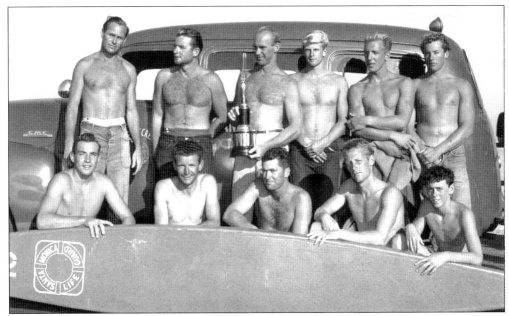

Members of Santa Monica's winning competition team pose together on the Santa Monica Pier; Pete Peterson holds the trophy. At far right, in the back row, is Mike Doyle, voted the best international surfer in 1966. He was inducted into the International Surfing Hall of Fame that same year with fellow Santa Monica lifeguards Pete Peterson and Buzzy Trent.

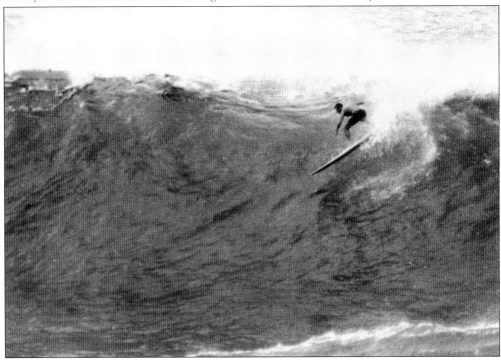

Lifeguards such as L.A. County's Greg Noll and Santa Monica's Buzzy Trent were trendsetters in popularizing the sport of big-wave riding in Hawaii. Here big-wave rider Fred Van Dyke charges down a large wave.

The surf on either side of Santa Monica's Pacific Ocean Park, including a small inside area on the former amusement pier's southern end, attracted large numbers of surfers. The area was made famous in the documentary *Dogtown and Z-Boys*, which chronicled the lives and exploits of several local skateboarders and surfers during the 1970s.

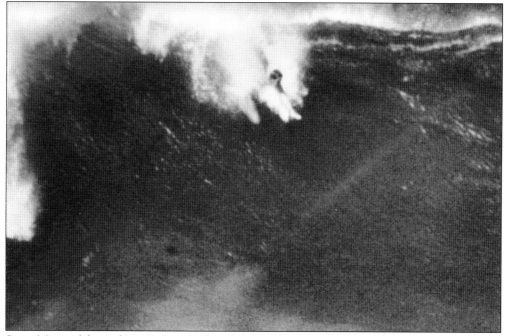

Santa Monica lifeguard Jim Graham bodysurfs down a large Hawaiian wave. Graham would become known as the "voice of the lifeguards" for his skill as an announcer at lifeguard competitions. Graham also became a professional announcer at beach volleyball competitions and often appeared on television.

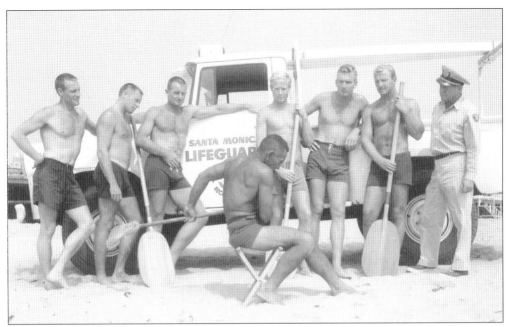

In 1959, the Santa Monica lifeguards put together their own outrigger team. Here they are coached in the "sweeping" action of rowing (hence the broom in the instructor's hands). The Santa Monica crew also built their own outrigger.

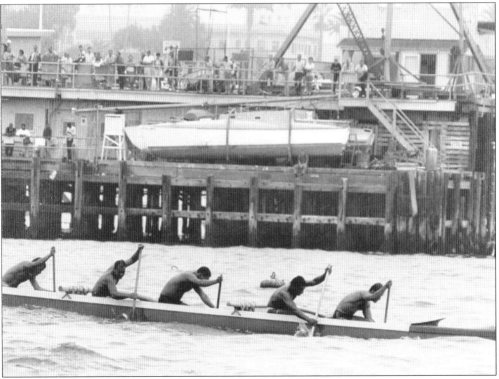

Moving fast in this photograph is an outrigger crew with the Santa Monica Pier in the background.

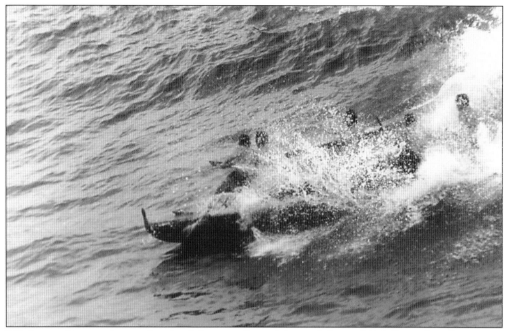

While standing on the south side of the pier, Santa Monica lifeguard Bob Sears shot this action photograph of the crew sliding down a wave in preparation for their upcoming competition in Hawaii.

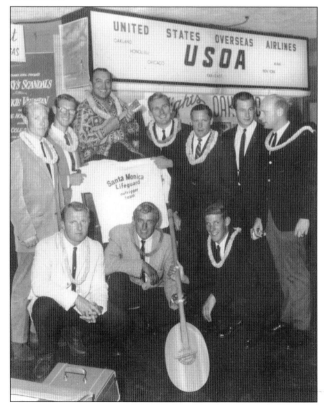

Excited outrigger team members gather in front of the United States Overseas Airlines desk before flying off to Hawaii. Ralph Cox, owner and founder of USOA, was always supportive of the lifeguards, and former Santa Monica lifeguard Frank Donahue was one of his key executives.

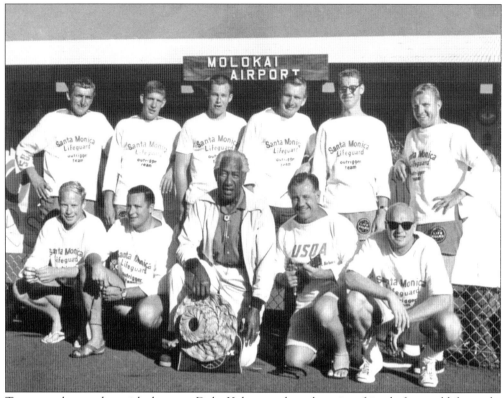

Team members gather with the great Duke Kahanamoku, a longtime friend of several lifeguards, including Norm Bishop, who is holding a ukulele.

Enjoying winter in Hawaii are Santa Monica lifeguards Joe Quigg (left), Matt Kivlin (center), and Tom Zahn. Today all three lifeguards are considered surfing legends.

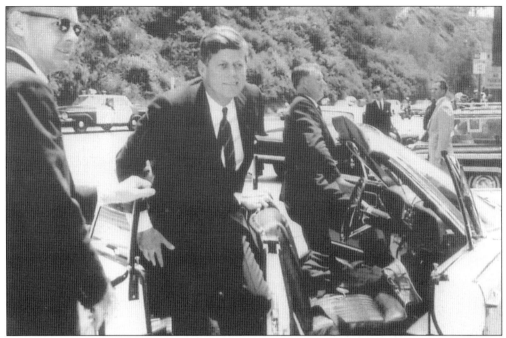

Pres. John Kennedy is seen exiting his car and heading to the front door of brother-in-law Peter Lawford's Santa Monica beachfront estate. Kennedy frequented the Lawford home and periodically swam in front of the "Western White House." When he did, he was always escorted by a Santa Monica lifeguard boat.

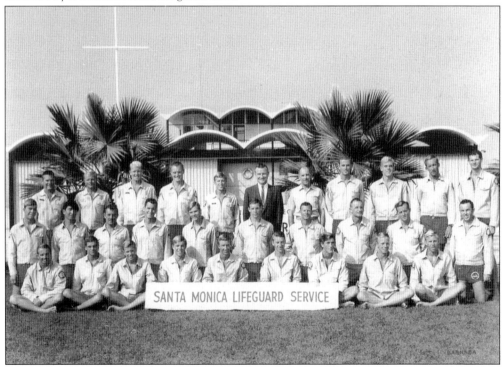

Pictured here are members of the 1966 Santa Monica lifeguard crew.

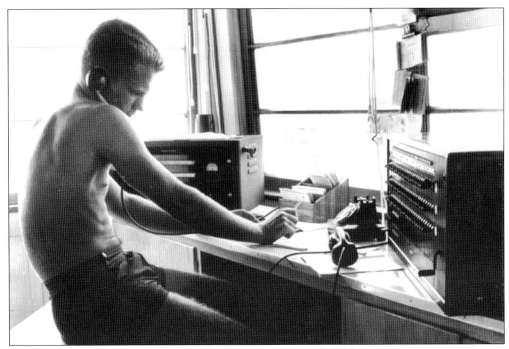
A lifeguard can be seen working a telephone switchboard inside the former Santa Monica lifeguard boat station. To his left is a radio for receiving and sending transmissions to boats at sea. The boat station was lost in the January 1983 El Niño storm.

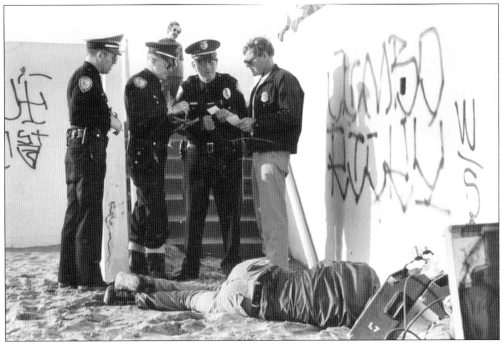
One of the legacies of the late 1960s was the number of drug overdoses the department had to deal with on the beach. Here lifeguard Tom Zahn meets with SMPD officers. An open resuscitator can be seen in the far right foreground, but attempts to revive the individual failed.

During the 1960s, many lifeguard services, including Santa Monica's, experimented with various technologies to improve rescue services. Here L.A. County lifeguards work with a sheriff's helicopter to evacuate an injured surfer.

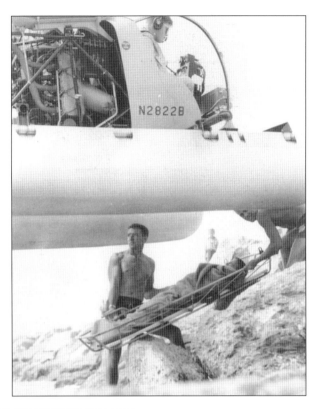

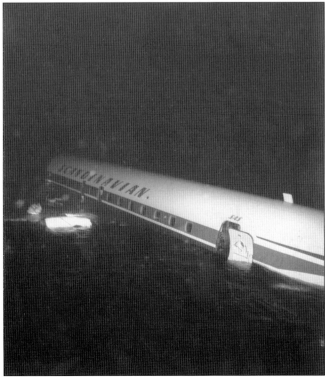

All three lifeguard services responded to reports of a downed Scandinavian airliner on the evening of January 13, 1969. Due to the speedy response of the lifeguard boat crews and other supporting agencies, rescuers were able to save 30 of the 45 passengers.

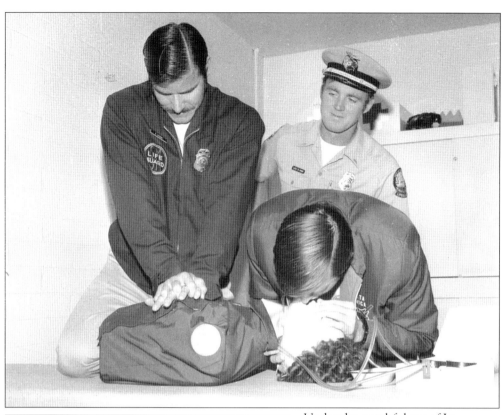

Under the watchful eye of Lt. Warren Rigby, Santa Monica lifeguards Paul Henne (doing compressions) and Randy Zeigler (rescue breathing) go through a CPR practice drill. (Courtesy of the Santa Monica Historical Society.)

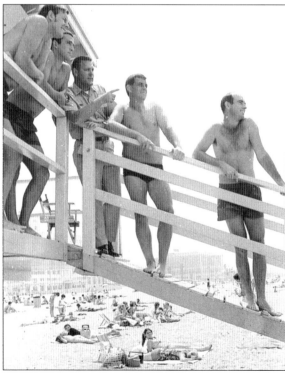

Santa Monica lifeguard captain Jim Richards gives instruction in water rescue extraction. (Courtesy of the Santa Monica Historical Society.)

Members of the crew can be seen carrying out their practice "victim." Drills such as these are used in competition by Australian and New Zealand lifesavers. In competition the event is know as a "Dummy Tow." (Courtesy of the Santa Monica Historical Society.)

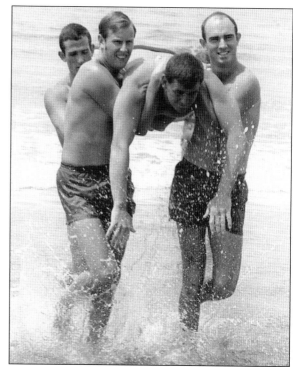

Lt. Gene Poole is seen at work inside the Santa Monica Boat Station, located on the bottom deck at the end of the Santa Monica Pier. Poole served, as did several other Santa Monica lifeguards, in the U.S. Navy's UDT (Underwater Demolition Team) program. It is known today as the Navy Seal program.

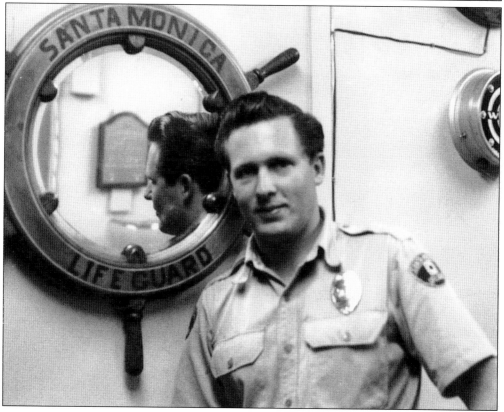

Santa Monica lifeguard Randy Zeigler is pictured standing next to a modern-day Peterson rescue tube. Although retired from lifeguarding, Peterson continued to produce the popular rescue tube from his boat repair shop at the end of the Santa Monica Pier. Peterson's rescue tube remains in use around the world today.

Originally from Michigan, Capt. Tom Johnson was a popular lifeguard. One of the funnier stories involving Tom was the time he was hired as a stuntman for the movie *The Last Voyage*, during which he had a 10-second close-up. When he returned to his small town in Michigan, the local movie theatre had listed the name Tom Johnson above the movie's title and its stars.

Santa Monica lifeguard John Howe is pictured in his dive gear getting ready for a practice dive.

Members of the Santa Monica lifeguard crew pose with their trophies after the 1969 winter games.

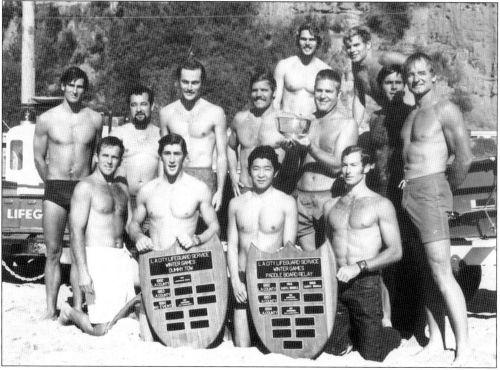

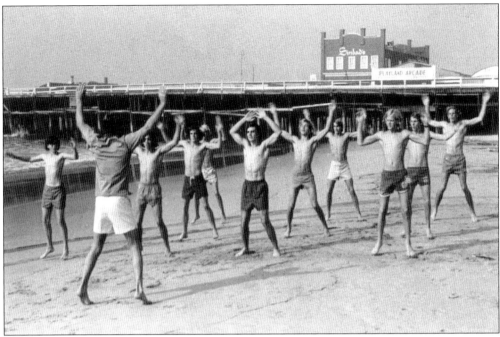

Lifeguard Terry Palma leads a winter training session for members of the Santa Monica Junior Lifeguard team that competed against various surf clubs in New Zealand in 1973. It was the first American junior guard program to compete there.

The once popular Sorrento Grill, behind today's Tower No. 8, was torn down in the early 1970s to make way for a condominium complex. The grill was a popular hangout for volleyball players, many of whom played at the international level.

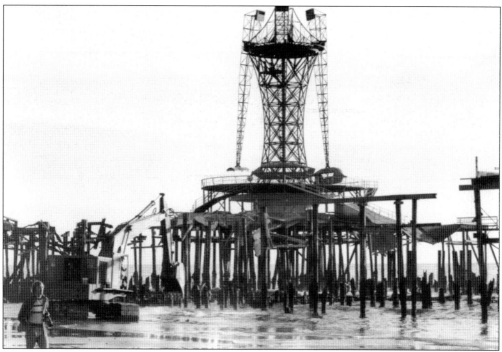

The 1970s also marked the end of the once popular Pacific Ocean Park. In 1975, lifeguard Nick Steers took this photograph of park's last days.

Paul Henne gives some advice to Tom Thorsen before an evening lifeguard competition in 1973. It was the last time Santa Monica competed as its own lifeguard service.

Two former Santa Monica lifeguards, Nick Steers and Gene Poole, reminisce about their days on the beach in front of one of the service's original rescue cans, now housed in the Los Angeles County Lifeguard Museum and Archives..

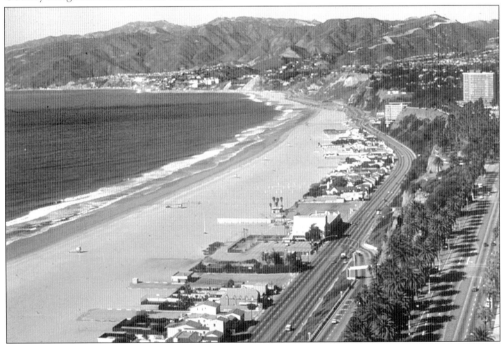

The beauty of Santa Monica Bay and the beach along Santa Monica North can be seen in this fall 1972 photograph.

Six

THREE LIFEGUARD SERVICES BECOME ONE
1974–2006

On July 1, 1974, the Santa Monica Lifeguard Service was folded into the Los Angeles County Lifeguard Service. One year later, the Los Angeles City Lifeguard Service followed suit. The merger proved to be beneficial for all. For taxpayers, it meant ending unnecessary duplication of services; for lifeguards, it afforded better training and promotional opportunities, as well as a better bargaining position for wages and salaries. By late 1975, the Los Angeles County Lifeguard Service was the largest in the world and its lifeguards the highest paid. In turn, it was also the busiest lifeguard service in the world, making an average of 10,000 rescues a year.

Lifeguarding on the beaches of Santa Monica has come a long way from the days of Cap Watkins, who rode a horse to make rescues. Today lifeguards working on Santa Monica Beach are members of the Los Angeles County Fire Department. In minutes, they can get assistance from Baywatch rescue boats, the Los Angeles County Fire Department, and U.S. Coast Guard helicopters. What has not changed, however, is that every lifeguard still enters the precarious ocean clad only in a red bathing suit to save the lives of those in need.

Currently staffed by a full-time crew of 120 and supported by 650 part-timers, the Los Angeles County Lifeguard Service remains a 24 hour a day, year-round operation, focused on the vigilant protection of the lives and safety of the beach-going public.

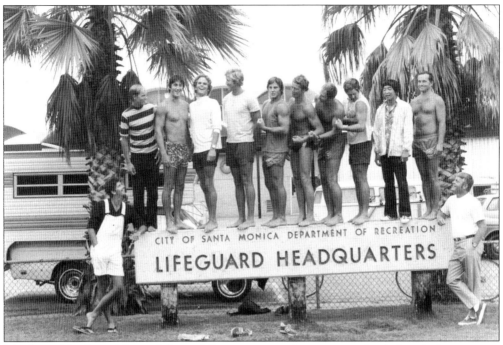

Members of the Santa Monica Lifeguard Service pose one last time together before the historic sign changed to reflect the merger into the Los Angeles County Lifeguard Service on July 1, 1974.

Longtime Santa Monica and Los Angeles County lifeguard Ron Brown hits the water in a rescue drill.

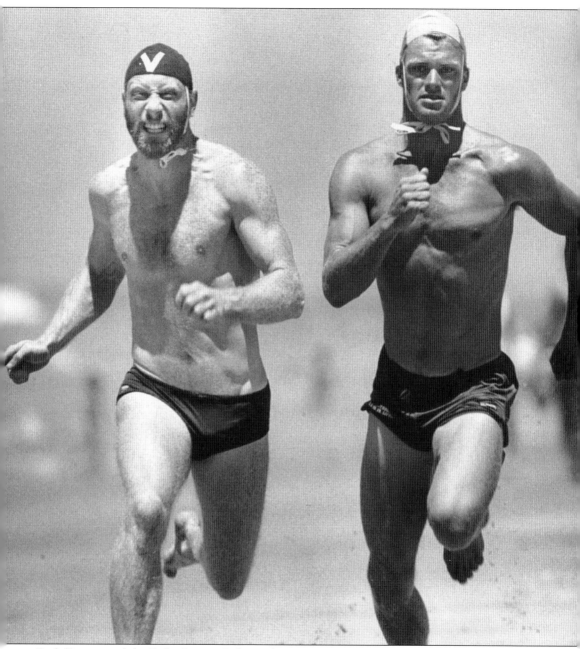

Rick Brouwer of the L.A. County Lifeguard Service races Australian Russ Middleton in an international lifeguard competition. Such competitions serve to exchange ocean lifesaving techniques and knowledge. They also encourage lifeguards to keep in top physical shape to make rescues.

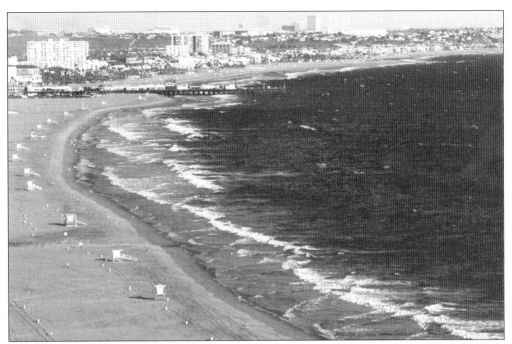

Award-winning photographer and Santa Monica lifeguard Tim Morrissey took this fall photograph of Santa Monica Beach. Morrissey continued to lifeguard while also serving as an official White House photographer during the Reagan and George H. W. Bush administrations.

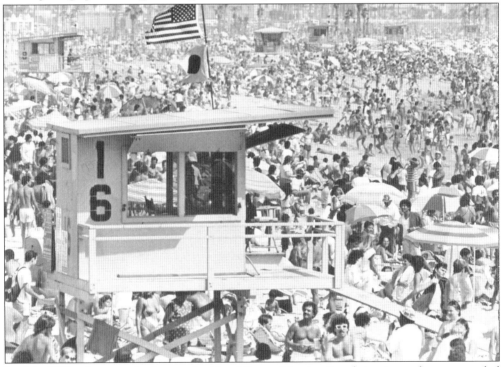

In this 1980s photograph, the south side of Santa Monica Beach is pictured on a crowded summer afternoon.

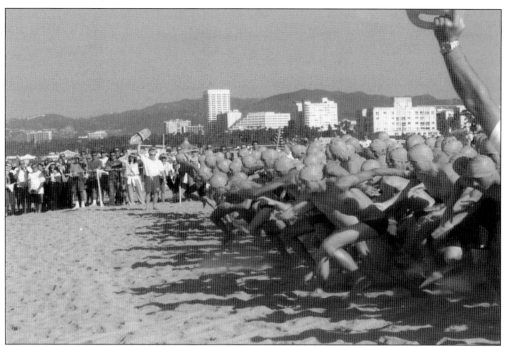

Over 300 swimmers qualified to take to the Los Angeles County lifeguard exam, seen here this September 2006 photograph. Only the top 70 finishers of the competitive 1,000-meter swim are interviewed for the 50 open spots in the service's training academy.

Candidates in the lifeguard academy hit the water during a competitive ocean swim race. Each candidate is scored on every aspect of the training program. Overall placement determines one's hiring priority.

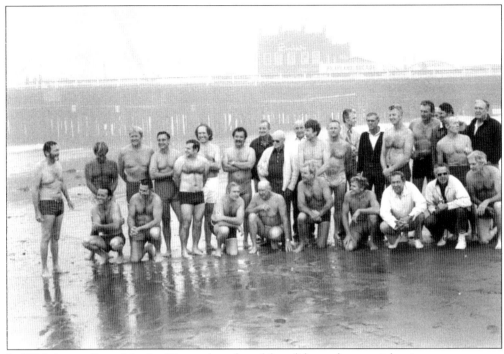
In 1986, former Santa Monica lifeguards gathered for a lifeguard memorial swim.

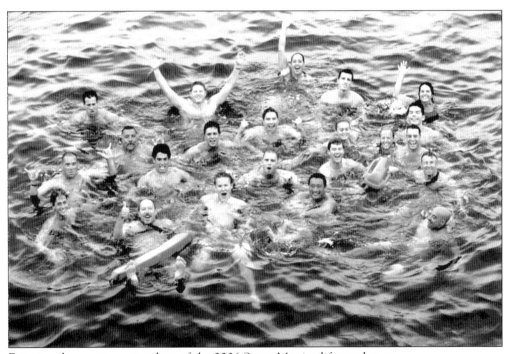
Enjoying the ocean are members of the 2006 Santa Monica lifeguard crew.

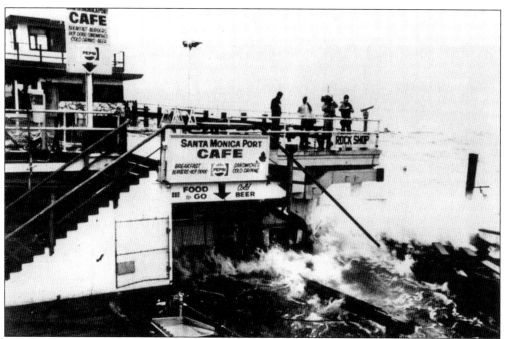

The El Niño storms of January 1983 proved fatal for the western end of the historic Santa Monica Pier. Here a television news crew captures the destruction of the pier's lower deck. Just a few hours later, the end of the pier, including the portion where reporters and camera crew had stood, collapsed into the sea. Fortunately, lifeguards and other rescue personnel had already evacuated everyone from the pier. (Courtesy of the Santa Monica Historical Society.)

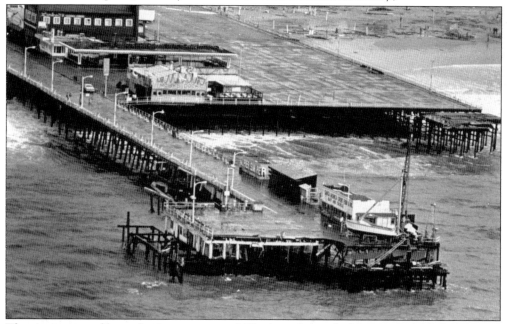

The pier is pictured here after it was evacuated. The lower left end of the pier is where the lifeguard rescue boat station had stood. Eventually the whole end of the pier collapsed, and to this day, it is significantly shorter than it used to be. (Courtesy of the Santa Monica Historical Society.)

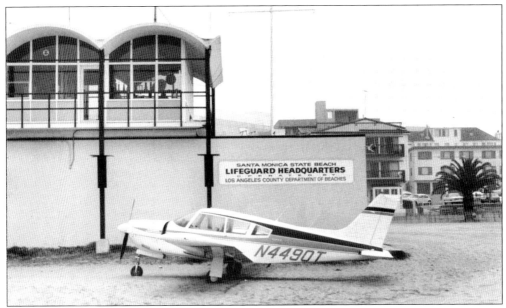

Under the flight path of Santa Monica Airport, the beach area of both Santa Monica beaches is sometimes used as last-ditch emergency landing area. Here a plane that safely landed on the beach is placed next to the lifeguard headquarters until it can be transported back to the airport.

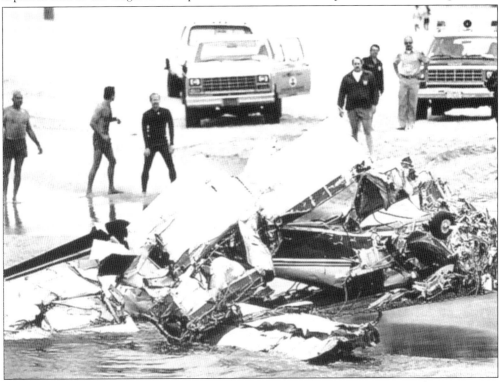

Sadly, lifeguards dispatched to this scene find the remnants of a downed aircraft with no survivors. On scene, from left to right, are guards Bob Chambers, Bill Austrias, Bruce Saylors, Ralph Lee, Don Spitler, and lifeguard chief Don Rohrer.

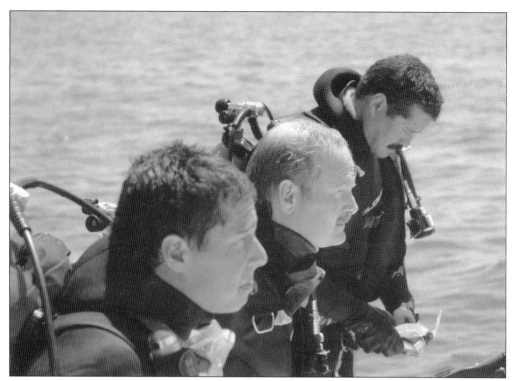

Perhaps the most difficult job in the lifeguard service is body recovery, but members of the L.A. County Lifeguard Dive Team prepare to do just that in this photograph. Lifeguard Drew Greger caught the solemn moment before the divers began their task of recovering two bodies from a downed aircraft. Pictured from left to right are Pat O'Neil, Don Olsen, and Brian Merrigan.

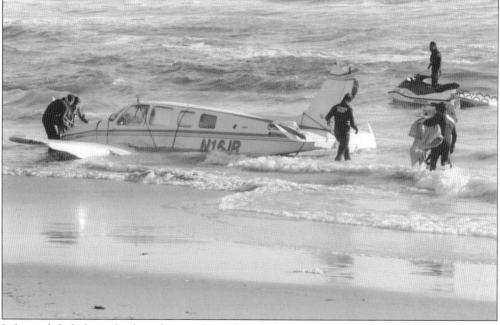

Lifeguards help bring back to shore a plane that crash-landed in the ocean.

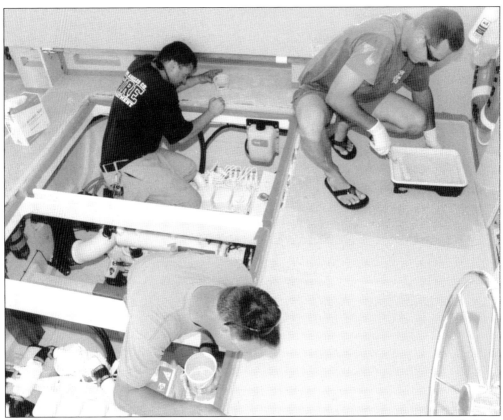

Painting and maintenance of L.A. County's 10 Baywatch rescue boats is a constant job. Here lifeguard and U.S. Navy veteran Eric Astorian (top left) assists Capt. Chris Lallone (top) and Capt. Brian Hogue (bottom) in getting a rescue boat prepared for operations.

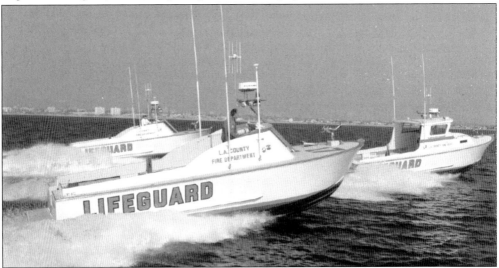

Here three Baywatch lifeguard boats practice a rescue drill. The front of the Baywatch boat is specially designed for large-scale rescue operations, including downed airliners. It remains on duty 24 hours a day.

Unbeknownst to the public, a Baywatch rescue boat speeds to a rescue off Santa Monica.

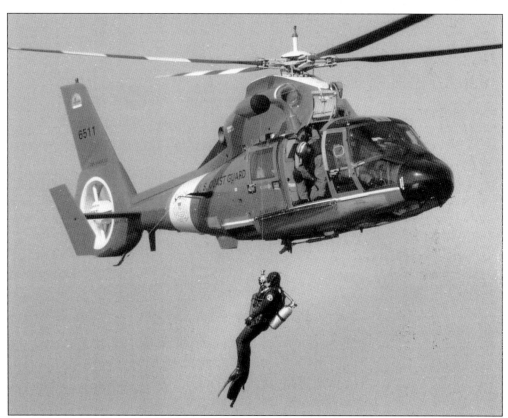
Both U.S. Coast Guard and L.A. County Fire Department helicopters play an important role in aiding lifeguards and the public. Here a lifeguard diver is hoisted up to a coast guard helicopter.

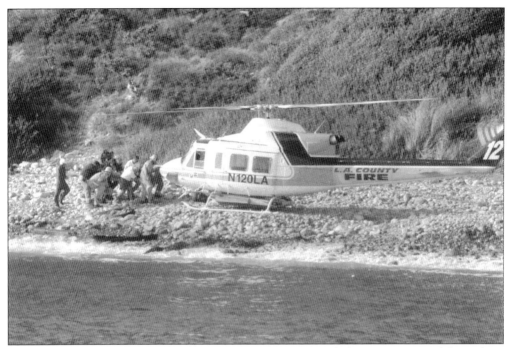

Lifeguard Phil Navarro took this photograph of a department helicopter assisting lifeguards in the evacuation of a seriously injured victim. As members of the L.A. County Fire Department, lifeguards can easily radio and communicate with all fire personnel.

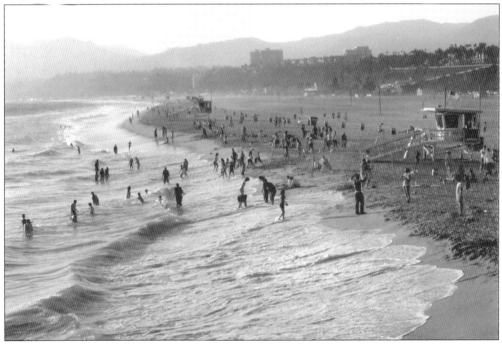

The Santa Monica Beach is popular year-round as one of Southern California's leading tourist attractions. Here bathers take in the sunset and an evening swim on the beach just north of the Santa Monica Pier.

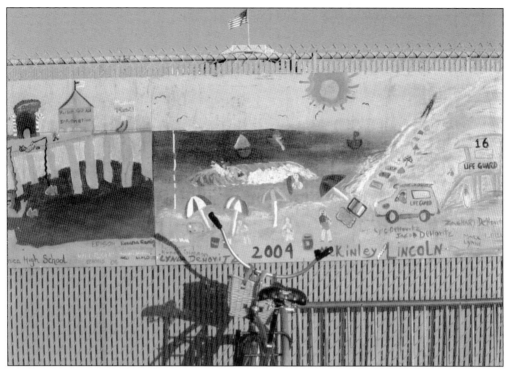

Students from McKinely and Lincoln Schools in Santa Monica were careful to put the lifeguards in their painting of life on Santa Monica Beach. The painting can be seen on the Santa Monica Pier.

International and nationally known artists have used lifeguard motifs to capture the feeling of California. Dutch artist Marjolijn Stolk painted this tower, capturing the ascetic beauty of these wooden sentinels in the sand.

Norton Wisdom, a retired Los Angeles County lifeguard and internationally renowned performance artist, created this well-known painting. Among the musicians Wisdom performs with is George Clinton.

Lifeguards never mind an extra pair of eyes watching over their water. Here guards Matt Rhodes (left) and Scott Deboer, along with a helpful seagull, watch over swimmers at Tower No. 26 in Santa Monica.

Considered one of the most difficult towers to work in the county is Tower No. 15, adjacent to the Santa Monica Pier. For over three decades, lifeguard legend Gabe Campos has worked to make sure everyone who visits there goes home safe and sound.

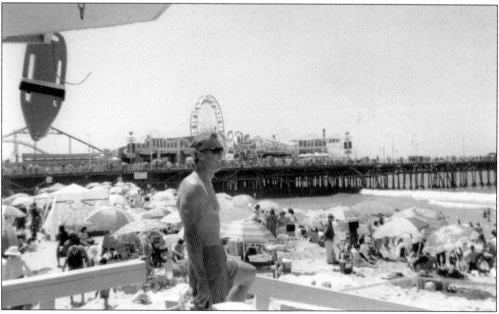

Checking out conditions at Tower No. 15 is Chief Phil Topar. A longtime veteran of the service, Topar has won several international lifeguard competitions, including two individual world titles.

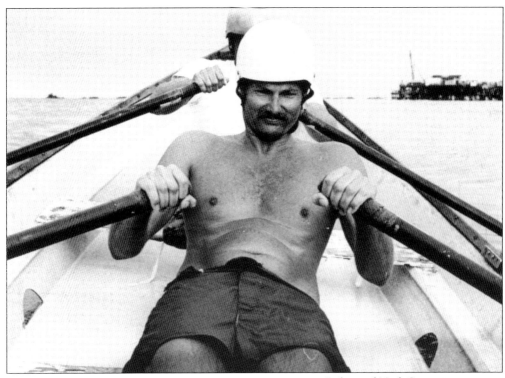

Lifeguard Nick Steers is seen preparing for an upcoming dory race. Held every summer, the races often attract large crowds of spectators.

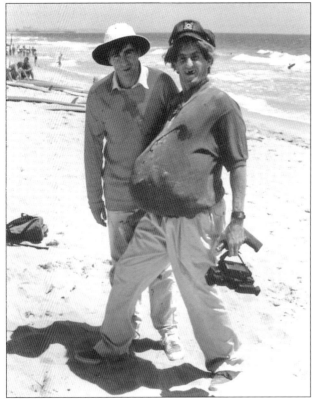

At the conclusion of every summer, each area has a lifeguard party. In 1990, the always-hilarious Mark Samet produced, directed, and starred as Skipper (seen in costume) in a lifeguard version of *Gilligan's Island*. Doubling as a full-time L.A. City firefighter, Samet was called on to bigger and better things, passing away on October 6, 2005. Gilligan remains grateful for all the laughter and memories he left behind.

Shannon Leavitt poses with a young beachgoer. The popularity of the television show *Baywatch* has helped make lifeguards feel like mini-celebrities among fans of the program.

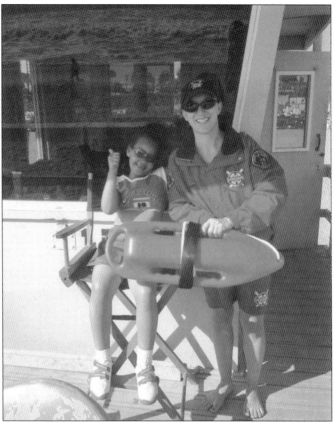

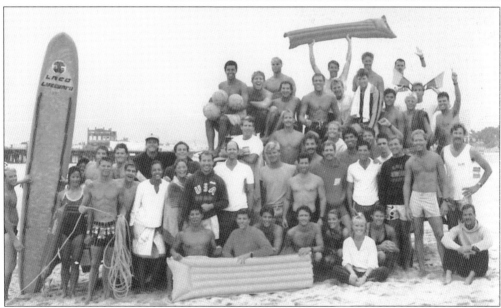

In 1986, Central Section lifeguards gather after a morning competition. Among the highlights was an "illegal plastic raft race," called so because plastic rafts are banned from use at the beach due to their lack of sturdiness in the ocean.

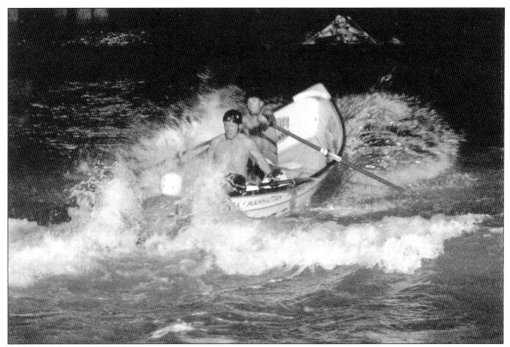

The first week in August is when many of the key evening lifeguard competitions are held. Among the largest in Southern California are the annual L.A. County Intercrew and the Judge Taplin lifeguard competitions. Lifeguard Joel Gitelson took this photograph of an L.A. County dory crew at a 2005 race at Manhattan Beach.

Celebrating a victory at a 1985 intercrew event are members of the Venice team. Win or lose, competitors always enjoy a party afterwards with their fellow lifeguards and friends.

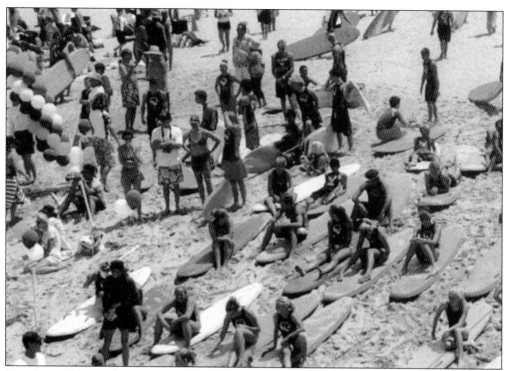
Here junior lifeguards wait their turn for an upcoming paddleboard competition. (Courtesy of Carrie Darling.)

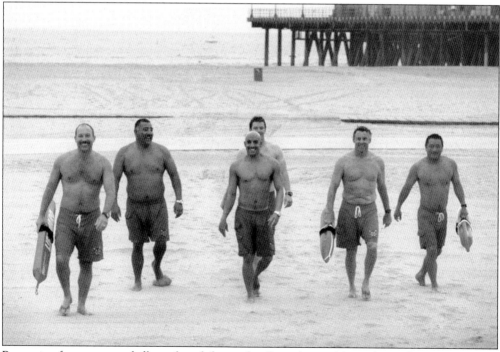
Returning from a rescue drill are, from left to right, Capt. Angus Alexander, Gabe Campos, Capt. Remy Smith, Frank Brooks, and Capt. Terry Yamamoto.

Capt. Angus Alexander is seen at the helm of one of the service's 10 Baywatch rescue boats.

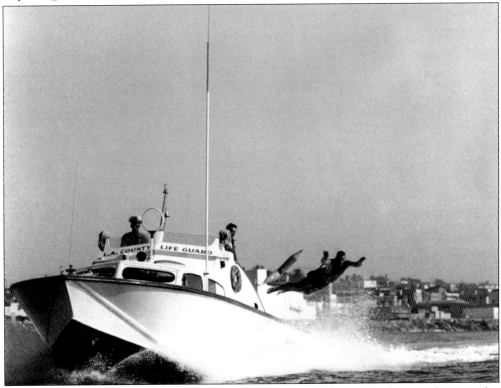
The Baywatch rescue boats have a long and proud history. In this 1950s photograph, a guard is seen doing a practice rescue dive off one of the very first L.A. County rescue boats.

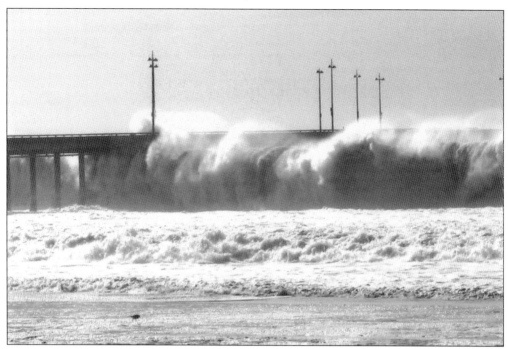

As seen in this December 2005 photograph, large surf is one of the obstacles lifeguards have to contend with in the performance of their job. These waves are breaking over the Venice Pier.

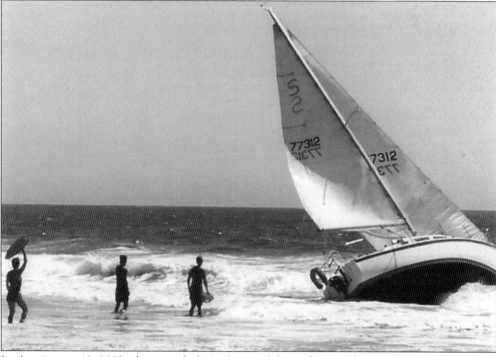

In this August 12, 2003, photograph, L.A. County lifeguards carefully approach a disabled boat whose owner has just jumped back onboard. According to the incredulous guards in the photograph, the owner then reappeared with a two-year-old child. (Courtesy of Shannon Leavitt.)

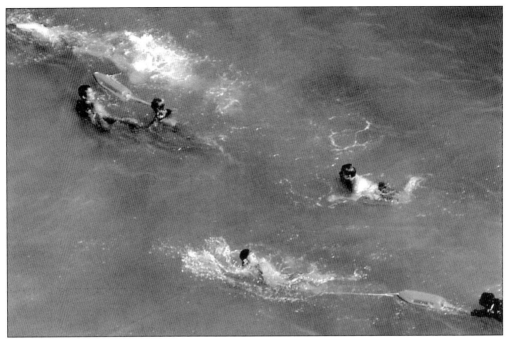

Aboard a Los Angeles County sheriff's helicopter, Capt. Nick Steers was able to capture this Labor Day 2004 Zuma Beach rescue in progress. The rescue broke so fast that the lifeguard at the bottom of the photograph was unable to remove his lifeguard cap. He can be seen wearing it backwards to allow better visibility in the surf.

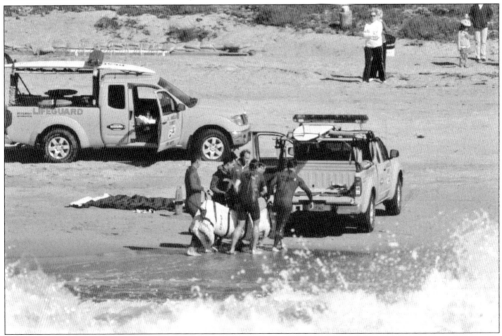

Lifeguard Phil Navarro took this photograph during the rescue of a sick dolphin. Lifeguards received international attention for their rescue of "JJ the whale." Later experts from Sea World safely returned "JJ" to ocean.

Capt. Erik Albertson has served as the Los Angeles County Lifeguard Association president since 2004. Also known by its initials "LACOLA," the association is responsible for representing the labor rights of county lifeguards. While president of LACOLA, Albertson has also served as a lifeguard captain on the beaches of Santa Monica and Venice.

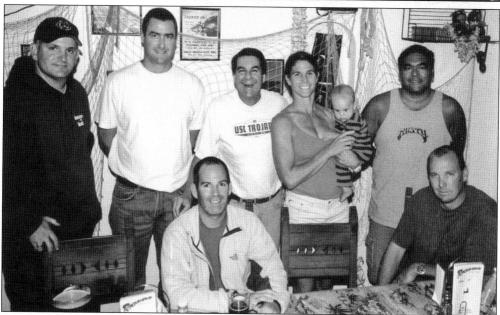

Once a month, LACOLA board members gather to discuss various issues involving their membership. From left to right are Olivier O'Connell, Steve Powell, Tim McNulty (seated), Arthur Verge, Virginia Rupe, the always well behaved Parker Rupe, Eugene Atanasio, and Erik Albertson (seated). (Courtesy of William Doyle.)

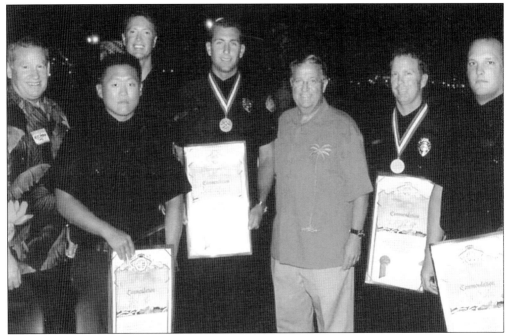

Pictured here at the 2006 Medal of Valor Awards ceremony are, from left to right, Los Angeles County fire chief Michael P. Freeman, Distinguished Service recipient Joshua Lee, L.A. County lifeguard chief Mike Fraser, Medal of Valor recipient Brian Lanich, Los Angeles County supervisor Don Knabe, Medal of Valor recipient Casey Culp, and Distinguished Service recipient Shawn Nolan.

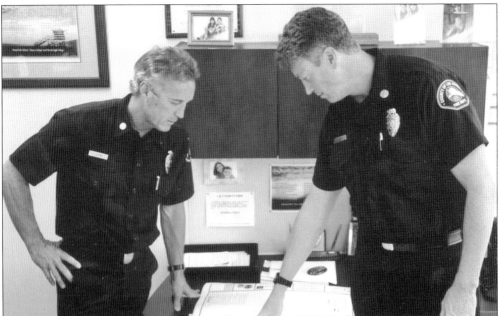

In this 2006 photograph, assistant chief lifeguard Phil Topar (left) and chief lifeguard Mike Fraser review plans for a future lifeguard substation. Under their leadership, new towers, stations, and two Baywatch lifeguard boats have been added to the service.

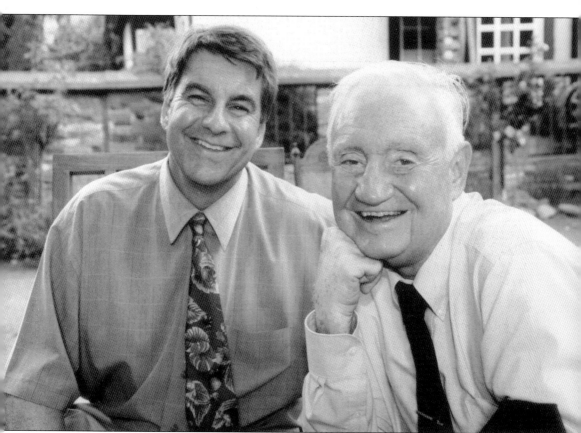

Author Arthur Verge is pictured here with his father, Art Verge Sr., who served as a Santa Monica lifeguard for 16 years and later became both a history professor and registrar at Santa Monica College. He was honored in 2005 for his 50-plus years of service to the Santa Monica School District. Arthur Verge Jr. began his career as a Santa Monica lifeguard in 1974, and he continues to work as both a lifeguard and a professor of history at El Camino College in Torrance, California. Also the author of Arcadia Publishing's *Los Angeles County Lifeguards*, he will be helping create the new Los Angeles County Lifeguard Museum and History Center. Those who wish to donate photographs or lifeguard memorabilia can contact him at arthurverge@aol.com. (Courtesy of Steve Wyrostok.)

Across America, People are Discovering Something Wonderful. Their Heritage.

Arcadia Publishing is the leading local history publisher in the United States. With more than 3,000 titles in print and hundreds of new titles released every year, Arcadia has extensive specialized experience chronicling the history of communities and celebrating America's hidden stories, bringing to life the people, places, and events from the past. To discover the history of other communities across the nation, please visit:

www.arcadiapublishing.com

Customized search tools allow you to find regional history books about the town where you grew up, the cities where your friends and family live, the town where your parents met, or even that retirement spot you've been dreaming about.